High Museum of Art

The officers, directors and employees of
Bank South are proud to have sponsored the
publication of this book.

High Museum of Art

The New Building: A chronicle of planning,
design and construction.
Published on the occasion of the dedication of
the new facility, October 6, 1983.

ISBN 0-939802-18-X
Library of Congress Catalogue Number
83-081150
Copyright 1983 High Museum of Art
All rights reserved
Published by the High Museum of Art,
Atlanta, Georgia
Manufactured in the United States
of America
First Edition

Copy and editing assistance was provided
by the following individuals:
Anthony Ames, Philip Babb, Vikki Baird,
Susan Berman, Bruce Galphin,
Richard Meier, Kelly Morris, Kate Norment,
Joan Ockman, Gudmund Vigtel and
Harriet Whelchel.

Photographs were provided by the
following:
Hedrich-Blessing, Chicago, p. 46 (fig. 4).
Lucien Hervé, Paris, p. 46 (fig. 2).
High Museum of Art Archives, Atlanta,
pp. 12-15
Museum of Finnish Architecture,
Helsinki, p. 47 (fig. 6).
O'Connor-Burnham & Company, Atlanta,
pp. 16-18, 49-64, 72.
Ezra Stoller © ESTO, Mamaroneck, pp.
39-44, 45 (fig. 1), 47 (fig. 5), 65-71.

Contents

Director's Statement

Gudmund Vigtel

There are times when certain elements seem to converge at a predestined point where they each can best serve the interests of a given project. This would appear to have been the case with the High Museum's new building, which has become a reality in four short years, thanks to several fortunate circumstances. When the forces that guided this project went into motion in 1979, a general conclusion had been reached by many individuals that the time had come to provide the museum with a better facility if it were to grow as a cultural factor in Atlanta. The dictates of a flourishing program had long made it clear that the museum's old and stagnant spaces would simply not suffice. An increasingly ambitious and maturing community would require much more.

The financial climate at that precise moment made possible some very large contributions which formed the basis for the subsequent capital campaign. From the museum's point of view, the time was right, moreover, for favorable terms in the construction industry. Beyond these basic factors—the museum's needs and good financial prospects—no other element was more important to the

realization of the building than the recognition on the part of strong leaders in the community that the time was right.

Fundamental to the success of all of this was the decision by the museum's great benefactor, Robert W. Woodruff, to get the project started by offering a challenge grant of $7.5 million. It was to be the driving inspiration to the many people who saw the building to its completion. Apart from the grant's size, no other source could have produced the generous response from private donors or business that this project received. We wish to record here our deepest gratitude to Mr. Woodruff for his enlightened support of the arts and to the president of the Woodruff charitable interests, Boisfeuillet Jones, for monitoring the project with intense interest and for timing the transfer of funds to our greatest advantage.

The museum's Board and the leadership of the Atlanta Arts Alliance were central to the execution of all plans for the building. It was the museum Board that held the whole operation together and I must single out a number of individuals who played significant roles in this regard: the three presidents

who served during this period, William B. Astrop, James P. Furniss, and Albert J. Bows, Jr.; the members of the Expansion Committee, James P. Furniss, H. Burke Nicholson, Jr., and Mrs. Rhodes L. Perdue, who gave direction to the realization of the project; and the chairmen of the four Task Forces selected by the Expansion Committee to lay out carefully reasoned plans, Mrs. Donald Stewart for the Task Force on Mission and Audience, Dr. John Howett for Departmental Emphasis and Space Needs, Albert J. Bows, Jr., for Design and Construction Arrangements, and Joel Goldberg for the Funding Resources and Approaches Task Force.

The crucial and difficult tasks of choosing the architect and the contractor were carried out by an eleven-person Building Committee under Albert J. Bows, Jr.'s wise leadership. Once the Committee's decisions had been made—and they proved to be absolutely right as time would show—the Construction Committee was appointed to oversee the museum's interests under the effective chairmanship of Mrs. Robert E. Wells, the other members being James E. Land and the Museum Director. Mr. Land,

Assistant Vice-President for Support Services of Southern Bell, made an outstanding contribution to the cost controls and overall supervision of the building with his extensive experience and sense of priorities. Without him the project would have been much diminished.

Fund raising, the lifeblood of any such undertaking, was accomplished with extraordinary speed and verve. More than $20 million was pledged beginning with Mr. Woodruff's inspiring challenge in December 1979, and by the time the building was completed 85% had been collected. Chief architects in the drive were Anne Cox Chambers, Chairman, and Ivan Allen III, General Chairman. Roberto C. Goizueta led the Major Gifts Committee and Mrs. Barrett Howell chaired the Board Solicitation Committee, with Mrs. O. Ray Moore as Chairman of Patrons Solicitation, and Mrs. Allen P. McDaniel as Chairman for Member Solicitation. Governor George Busbee served as Chairman of "Friends in Georgia," and A. Anderson Huber led the special committee on the Callaway Challenge Campaign. I wish to make special mention here of Mrs. Rhodes L. Perdue, who coordinated

the campaign with great insight, of Charles R. Yates, President of the Atlanta Arts Alliance, who was, as always, an enthusiastic and highly effective campaigner, and L. Edmund Rast, Chairman of the Alliance Board, who played a significant role in relating the museum project to the business community and who was largely responsible for the successful negotiation with the City's Library Board for the acquisition of the branch library land on our block. The Alliance Treasurer, John W. Spiegel, played an important role in monitoring the finances of the project.

Mr. Allen's determined leadership, with the guidance of Mrs. Leonard Haas of Haas, Coxe and Alexander and the participation of the individuals mentioned above, as well as hundreds of volunteers under the superb leadership of the Members Guild, put together a campaign for the visual arts which has seldom been matched in smooth execution, if ever. Their efforts were supported with great effect and much style by our public relations consultant, Jack Burton, and the firm Burton-Campbell, Inc. Burton-Campbell contributed their services at no charge. Thanks to these and other impor-

tant factors, the new High Museum building has enjoyed international publicity which must be said to be quite extraordinary.

The generosity of our donors has also been out of the ordinary. Mr. Woodruff set the example and our own Board of Directors followed suit with contributions of more than $5 million. When the campaign needed extra impetus last summer, the Callaway Foundation of LaGrange, Georgia, stepped in with a significant challenge grant which proved instrumental in putting the campaign over the top. It is interesting to note that some 60% of the total goal was contributed by fewer than a dozen people. The total amount came from over 2,500 sources. All but 3% was given by people in Georgia. The goal was reached without grants from the City, the County, the State or the Federal Government. The fact that 9 out of 10 donors were High Museum members says something for the importance of that source of support in the campaign.

For all the good will lavished on our building project, success might still have evaded us were it not for the mutual trust and close collaboration between the museum as client

10 and the architect and contractor. Richard Meier created a brilliant design for a museum building which met our requirements for an enjoyable ambiance and a combination of carefully controlled spaces which would effectively serve the needs of our operation. It is to Mr. Meier's great credit that the building's distinctive qualities grew out of the detailed program which had been prepared by us and that his design included all of our specifications for particular spaces, their purposes and their interrelationships. He did this and added to it his unique sense for light-filled spaces held, defined, and related to each other by a series of judiciously chosen shapes and materials.

No contractor could have built this intricate design better than Beers Construction Company of Atlanta. Their well-known integrity and sense of commitment to their client, and their professionalism gave the building its pronounced quality of excellence. We are in great debt to the firm's president, Lawrence L. Gellerstedt, Jr., and his dedicated staff for giving us such a museum building without allowing the costs to exceed our budget, and, what's more, completing it on its original schedule.

No one was more deeply involved on a day-to-day basis than the museum's Expansion Project Director, Vikki Baird, both in all details of the elaborate fundraising scheme and in the coordination of the museum's interests with the complex procedures of the architect and the contractor. She handled all elements in these activities with great resourcefulness and a relentless attention to detail. Also, tribute should be paid here to the museum staff for their enthusiastic support and participation.

As in all undertakings brought to a successful conclusion, this project is the result of the perseverence on the part of many energetic and capable individuals. It was carried out in an unusual spirit of single-minded purpose. Beyond this I should say that, perhaps most remarkable of all, it was dominated by a most agreeable atmosphere of unselfish intent and mutual good will. For all of this we should be infinitely thankful.

We wish to extend special appreciation to Bank South for their generous sponsorship of this publication.

Project History

As the Campaign for the New High Museum went public in 1981, thousands of bumper stickers drove the message home and around town: *Help Build a Museum Big Enough for Atlanta.*

That fund-raising slogan succinctly capsuled the essence of a long-range planning study prepared by a special committee of the High Museum's Board of Directors seven years before. The museum's future, it reported, was directly related to finding more space.

Director Gudmund Vigtel had been quoted in the 1974 Long Range Planning Report: "The success of our future rests squarely on our ability to increase our space. Improving our collections with discernment will be absolutely essential, but services to the community in terms of education and recreation are going to be crucial to our future success. We will be measured by the growth of our collection, but we can survive as an institution only on our usefulness to the community. All this implies much more space than what we have now."

The formal findings and the projected space needs were no surprise to the Board, the museum staff, patrons and other art-lovers of the region. At most, the museum could display only 20 percent of its permanent collection at any given time, and lack of space severely limited its ability to host traveling "blockbuster" exhibitions.

But then the museum had a history of outgrowing its space. Its first home was the J. M. High family residence on Peachtree Street, donated in 1926. It had no space specifically designed for adequate display until 1955, when it moved into a new brick building adjacent to the old mansion. The Memorial Arts Building was constructed in 1968 in honor of the 114 Georgia art patrons who were killed in a Paris plane crash while on a museum-sponsored tour. This building wrapped around the museum's brick building, but the museum's usable space did not grow significantly. Once enclosed, the museum had no further space for expansion.

The 1974 report, with its conclusion that the High Museum should have a building of some 250,000 square feet in the 21st century, was just a wish-book when it was issued. The time was not ripe for a major fund drive.

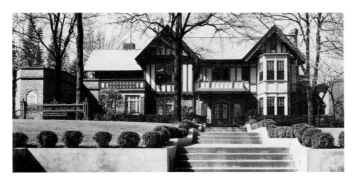

In 1926, Mrs. J.M. High donated her home on Peachtree St. as an art museum and school. In 1928, the High Museum of Art opened to the public.

Five years later though, the need was even more obvious, and the means for achieving a new museum began to evolve. The key element, as it had been for the Arts Alliance itself and for many other worthy Atlanta projects, was the interest of philanthropist Robert W. Woodruff.

The potential of this vital support prompted the museum's leadership, in February 1979, to authorize Heery & Heery, Architects & Engineers of Atlanta, to produce a feasibility study of space for a new building on the Arts Alliance block and an estimate of costs for construction. This study concluded that a building of 150,000 square feet could be constructed on the land immediately north of the Memorial Arts Building at an estimated cost of $15 million.

That summer, Board President William B. Astrop appointed an Expansion Committee consisting of the late James P. Furniss as chairman, Mrs. Rhodes L. Perdue and H. Burke Nicholson, Jr. as members, and Director Gudmund Vigtel as ex-officio member. Nicholson in turn developed a plan for dividing research and planning assignments among Task Forces drawn from Board membership. The museum Expansion Committee, together with its four task forces, had the duty to see that an orderly approach was made to the contemplated project and to define and set in motion the necessary advance studies, procedures, and organizational arrangements.

As director and coordinator of the expansion project, the Committee appointed Vikki B. Baird, who by education, experience, and interests was especially qualified for the work. She previously had served the National Endowment for the Arts as legislative assistant under Chairman Nancy Hanks.

The Task Forces provided the research and planning that undergirded later construction and fund-raising phases of the project. Their specialties were divided into four main areas of research:

Mission and Audience: Examined the principal purposes and aims of the High Museum, analyzing audiences and goals in terms of services and programs. Mrs. Donald Stewart served as chairman and Mrs. C. Peter Siegenthaler as coordinator.

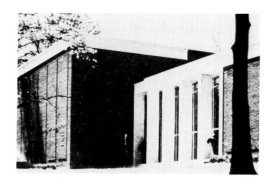

The Museum remained in the High mansion until 1955 when the building was razed in order to construct a brick, climate-controlled facility of approximately 30,000 square feet.

Departmental Emphasis and Space Needs: Recommended allocation, organization and distribution of space by department and function. John Howett was chairman and Mrs. Ronald W. Hartley coordinator.

Design and Construction Arrangements: Established procedures for selecting an architect and general contractor, and a system for project supervision. Albert J. Bows, Jr. was chairman, and Mrs. Robert E. Wells and Mrs. W. Donald Knight, Jr. served as coordinators.

Funding Resources and Approaches: Recommended plans for a fund-raising campaign. Joel Goldberg was chairman and Mrs. Crawford Barnett, Jr. was coordinator.

In developing their recommendations, the Task Forces worked in close collaboration with the Expansion Committee, Director Gudmund Vigtel and other members of the museum staff, as well as key individuals in the Atlanta community. Over a four-month period, the work involved approximately 50 people from the Board of Directors who visited some 25 museums in the country, consulted many advisors in museum design

and construction, attended more than 75 meetings and dedicated countless volunteer hours to the project.

The Task Forces completed their work and made final reports and recommendations in December 1979. These reports were accepted by the Board with fortuitous timing, because in December of that year Mr. Woodruff's $7.5 million challenge grant was announced to the public. Its terms required that the challenge be met dollar-for-dollar within three years, or by the end of 1982. In making the grant to the museum, Mr. Woodruff said, "It is vitally important to Atlanta's cultural and economic life to have an outstanding museum capable of attracting and exhibiting the finest products of our world's heritage."

Woodruff's commitment propelled the project from research, study, and recommendation into action. The operational phase fell into two principal parts: 1) design and construction and 2) fund raising.

Immediately, a Building Committee was created, charged with choosing an architect and general contractor, overseeing the de-

14

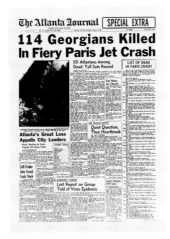

The Atlanta Journal | SPECIAL EXTRA

114 Georgians Killed In Fiery Paris Jet Crash

Headlines from June 1962 tell of the tragic crash of the chartered flight of 114 Georgians traveling to Europe on a museum-sponsored art tour. The next year the Atlanta Arts Alliance was incorporated, and in 1968 the new Memorial Arts Building was dedicated to the memory of those who perished.

sign and construction (through a construction supervisory group), and monitoring costs and budgets. Albert J. Bows, Jr. was named chairman of this vital group.

A general description of the project announcing the search for an architect was well publicized in architectural journals of February and March 1980. The announcement specified criteria for interested architects: museum or related design experience, a good record of adhering to schedules and budgets, a willingness to commit "specific, experienced talent," and to work within budgetary constraints.

From the initial list of more than 75, some 50 architects submitted their credentials by April 1980. The Building Committee carefully reviewed each proposal and narrowed the number to 15 extremely qualified prospects. More detailed submittals were requested and each firm was asked to describe, among other things, his philosophy of art museum design.

By May the Committee had reduced the list to six firms and each of these was invited to appear before the Building Committee and

the museum's curators, to make a 30-minute presentation and participate in a one-hour question-and-answer session.

The Committee was unanimous in selecting Richard Meier, based on his past work, his understanding of art and art museums, his previous clients' enthusiasm for his integrity and professional excellence, and for his position as a leading designer in the field of architecture. The Committee found it particularly significant that Meier was the only candidate among the six who appeared by himself, rather than with a team. His associates, of course, included architects with various specialized disciplines, and they were to be much involved throughout the project, but his solo performance emphasized and foretold his firm grasp of all aspects of the project. That all-inclusive role and the personal involvement of Meier continued throughout the design and building phases, from contract negotiation to the final days of construction.

By summer of 1980, eight major Atlanta-area contractors had made presentations for the construction job. Beers Construction Company's contract proposal, its extensive

The Memorial Arts Building currently houses the Atlanta Symphony Orchestra, the Atlanta College of Art and the Alliance Theatre.

experience, the integrity of its principals, and its demonstrated commitment to the betterment of Atlanta made it the clear choice of the Construction Committee.

Meier's ultimate design for the new museum evolved not only from his own esthetic sense, but also from parameters established by a well-defined program written by Director Gudmund Vigtel. This document outlined key areas of operation such as audience, staff and volunteers, programs and services, the collection, and security and energy control, and gave specific space allocations for exhibition, administration, and support functions. This written plan became the basis for many key decisions related to design and layout, and was used as a roadmap in planning the new facility.

Museum officials wanted a functional design accommodating the realities of museum operation, inflation and energy control, and yet the building needed to be a work of art itself, a showpiece of craftsmanship. It should invite the visitor inside to its displays and activities, and create a calm, harmonious environment for easy viewing and logical progression.

It was important for the new structure to harmonize with its neighbor, the Memorial Arts Building, which would continue to be home for the Atlanta College of Art, Alliance Theatre, Atlanta Symphony Orchestra and the umbrella organization of the four components, the Atlanta Arts Alliance. The design furthermore needed a clear sense of orientation, not only internally, but also in its relationship to the Memorial Arts Building and the area's other principal landmark, Peachtree Street.

The limited available site of approximately two acres dictated a multi-story structure. The site included a small Atlanta Public Library branch at the corner of Peachtree and 16th Streets. The building was in poor repair, and the Library Board, after long negotiations, was amenable to selling the property. The Arts Alliance under Board Chairman L. Edmund Rast made several proposals that would have allowed Library services to continue within the Memorial Arts Building, or to consider the purchase of another building for the Library's operation, but in the end the Library Board opted to accept a cash purchase offer for the building and land.

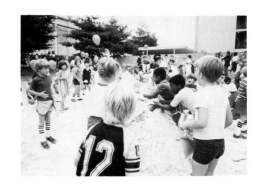

With Board approval of the design, ground was broken in July 1981, aided by hundreds of children supplied with red shovels bearing the campaign slogan.

Original plans called for a one-year design process and a two-year construction period, a rigorously tight schedule for a complex project. But this plan proved feasible. Richard Meier was selected in June 1980, groundbreaking was in July 1981, and the museum's staff and collection were completely moved by August 1983.

Meier studied the museum's requirements at length, visited the site many times and conferred in great detail with the museum's project representatives. In April 1981 architectural drawings were released to the public for the first time. A six-level structure built around an atrium core was revealed and included a ramp system providing both pedestrian access and visual connections between the floors. In presenting the plans, architect Richard Meier said: "The building is designed to welcome the visitor, to arouse interest and curiosity and yet convey its sense of purpose as a contemplative place. It is a many-faceted structure, not intended to awe or overwhelm. It presents a variety of spaces, scales and views, while maintaining a clear relationship of the architectural parts, so that the visitor really retains his orientation."

Fund raising proceeded with gratifying speed. Woodruff's 1979 challenge grant, amounting to half the total construction cost, was a vital boost to the campaign. The museum's Board of Directors, with 100 percent participation, put the campaign in high gear by additionally pledging more than $5 million between June and September 1980. Many key Board gifts set the tone for other phases of the campaign. Major gifts from corporations and foundations, response from the museum's 11,000 members, and contributions from the general public thrust the drive well beyond the goal of matching Mr. Woodruff's challenge grant, one full year before the deadline.

The $15 million goal covered only construction, however. Another $5 million was needed to cover all design fees, engineering services, consultants, landscaping, and expenses related to equipment for display, storage and care of art works, auditorium furnishings, services and interior needs.

By August 1982, the Campaign for the New High Museum was within $2.7 million of reaching the $20 million target. The Callaway Foundation of LaGrange, Georgia then

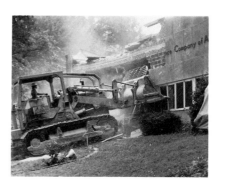

Demolition of three existing buildings on the site began in August 1981. Grading and excavation continued into November.

offered a $900,000 challenge grant, to be matched two for one, by the end of 1985. The Campaign surpassed the $20 million goal in the summer of 1983, assuring complete funding for the project well ahead of deadlines and opening dates.

With early construction funds committed and Meier's design approved, groundbreaking was held July 30, 1981. It was not the ordinary ritual, but one appropriate to the future of the new museum: A crowd of hundreds of exuberant Atlanta children dug into a large area of sand covering the site, using red shovels bearing the legend "I helped build a museum big enough for Atlanta." A brass band played and balloons were launched, with bulldozers poised at the periphery.

Foundations were poured in December 1981, and construction proceeded without interruption through the fall of 1983. Once the museum leadership had approved the design in concept, refinements were made to adhere to budget and functional parameters. The project followed a tripartite system of operation, with close collaboration between the client, architect, and general contractor.

The museum was represented by its Construction Committee, consisting of Mrs. Robert (Jean) Wells, chairman; Director Gudmund Vigtel, and James E. Land, Assistant Vice President of Support Services at Southern Bell. As the group's building professional, Land served for three years and worked closely with the contractor to identify areas of design or construction modification for significant savings, keeping the project within its budget at each critical stage. Mrs. Wells represented the Board throughout the process and Vigtel contributed professional expertise to all areas affecting the museum's operation.

Almost as remarkable as the building itself is the unfettered pace at which it was conceived, funded, and completed. The hint in early 1979 that a major Woodruff grant might be forthcoming inspired an intense nine-month period of planning. That groundwork was vital to the project's uninterrupted schedule and the meshing of the success of the fundraising campaign with the building itself. Once Mr. Woodruff's challenge grant was announced, the project moved almost without pause to architect selection, design, and construction.

18 The extraordinarily positive comments Richard Meier's design has received in the international press throughout the construction period reinforce what Atlantans have observed firsthand as the new museum has risen from its foundations.

The end result of the creative input and the harmonious collaboration of all involved is an expression of an exceptionally gifted architect. A concept of highest integrity has been interpreted with consistent quality of design and craftsmanship. Functional requirements have been translated into an esthetically satisfying balance of natural setting and imaginatively varied interior space—an environment for the visitor's private enjoyment and contemplation.

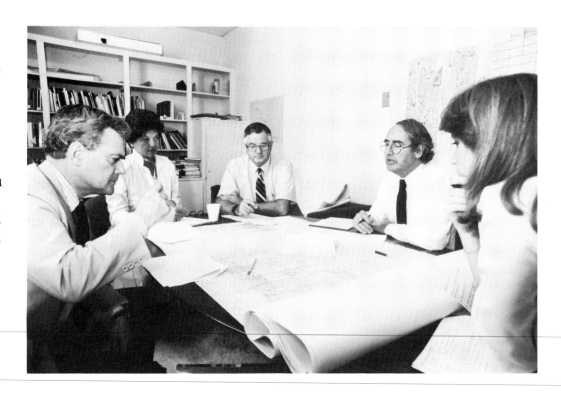

Architect's Statement

Richard Meier
FAIA

Most of the great European museums, which during the Age of Enlightenment came to have an educational as well as collecting role, are conversions from grand residences or palaces. The objects are seen in natural light in the environment for whose scale they were created. Today, the scale of the objects and of our expectations has changed, and natural light is considered harmful to the objects themselves. The High Museum of Art refers to the typological tradition of the Enlightenment and attempts to resolve the best of the old and modern notions of the art museum. Our intent is to encourage discovery of aesthetic values and to convey a sense of the museum as a contemplative place. The circulation, lighting, installation, and spatial qualities of the design are intended to encourage people to experience the art of architecture as well as the art displayed.

The design of the High Museum developed as a series of architectonic responses to context in the broadest sense, understood to include not only functional, programmatic, and typological concerns, but also the physical, social, and historical context of the city. The corner site for the building, at the junction of Peachtree and Sixteenth streets about two miles from downtown Atlanta and adjacent to both the large Memorial Arts Building and First Presbyterian Church on Peachtree, places the museum at an important location for Atlanta's future development, and within a pedestrian-oriented neighborhood with good public transportation access nearby. The *parti* consists of four quadrants with one carved out to distinguish it from the other three—the missing quadrant becomes a monumental quarter-circle glazed atrium. As the treed frontage on Peachtree is especially beautiful, and as traffic patterns indicate an entry on this active and historic thoroughfare, the atrium quadrant is the one adjacent to the Memorial Arts Building, and the building, set well back from the street to allow the green space in front to be preserved, is entered by way of a long ramp projecting out of the building on the diagonal of the site, which takes the visitor along a screen wall, through a portico, and into the main level of the building.

The extended exterior ramp is both a symbolic gesture reaching out to the street and city, and a foil to the tensile—here

quarter-circular—interior ramp which is the building's chief formal and circulatory element. The diagonal of the entry ramp plunging into the heart of the building disrupts the classical four-square symmetry of the plan, setting in motion more turbulent geometries which successively inflect the architectural order.

The cubic volume at a forty-five degree angle to the building on the left of the entry ramp is a 250-seat auditorium, separate from the main body of the building for reasons of access and security; its location reinforces the entry and forms part of the processional sequence. This volume is entered through a neck between a convex wall and the volume itself, and exited by a ramp running in reverse alongside the ingoing ramp, producing a continuous loop into and out of the auditorium.

At the end of the ramp on the right is a piano-curved element; this is the main entry/reception area, from which one passes into the four-story skylit atrium. To some extent this dramatic central space is inspired by, and a commentary on, the Guggenheim Museum. Curved-ramp circulation and gallery spaces encircle the atrium, which becomes the fixed point of reference for movement around the galleries. As in the Guggenheim, the ramp system mediates between the light-filled central space and the art itself, which may be seen and reseen from various levels, angles, and distances as one moves upward. The problem with the Guggenheim is that the ramp is made to double as a gallery, inducing a propelling motion that is inappropriate to contemplative viewing. The sloping floor plane, ceilings, and walls are not only uncomfortable, but by suppressing the datum of the right angle, make the display of paintings especially difficult. In Atlanta, the separation of circulation and gallery space overcomes these problems while maintaining the virtue of a central space governing the system of movement. This separation also allows the atrium walls to have windows which admit natural light and offer framed views of the city, while the galleries can receive both natural and artificial light depending on the requirements of the art displayed. The galleries too are organized to provide multiple vistas and cross-references, intimate and larger-scale viewing to accommodate the diverse needs of the collection, and glimpses

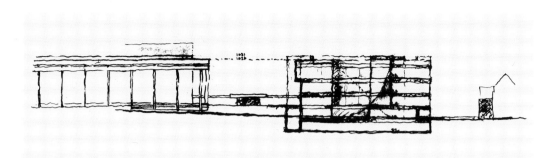

across the atrium from one exhibition space into another. Here the spatial variety, together with the clearly apparent relationship to the plan parts afforded by the atrium, helps alleviate the experience of fatigue that one often succumbs to in many large museums.

Programmatically, the 135,000-square-foot building includes 46,000 square feet of gallery space. Off the ground floor court are a conference room with a kitchen, a museum shop, a members guild office and, behind a wall used for exhibiting new acquisitions, curators' and director's offices, staff spaces, and board room. The counterclockwise ramp circulation to the upper-floor galleries takes one roughly chronologically through the history of art; stairs and an elevator provide alternative means of circulation. The top floor is shared by twentieth-century art and loan exhibitions; built-in flexibility allows the loan space to expand into the twentieth-century space as necessary in order to accommodate major shows. The auditorium, separate from the main building at entry level, may be entered from within at the second level, where the balcony access allows it to function as an integral part of

the museum when desired. On the floor below the main level are the educational spaces—junior gallery, lecture room, workshops, department offices—which have their own entry off Sixteenth Street, so that children coming by bus can be dropped off here and come directly into the building under cover. Storage areas and other service spaces are also located on this level.

The structure consists of steel columns and frame and concrete slabs. The granite base (and flooring on the main level) acts as a horizontal datum for the ramps and an anchor for the white porcelain-enameled panels cladding the galleries above.

Light, whether direct or filtered, admitted through skylights, ribbon glazing, clerestory strips, or minimal perforations in the panel wall, is a constant preoccupation throughout: apart from its functional aspect, a symbol of the museum's role as a place of aesthetic illumination and enlightened cultural values. The total architecture is intended to encourage the discovery of these values, and to foster a contemplative appreciation of the museum's collection through its own spatial experience.

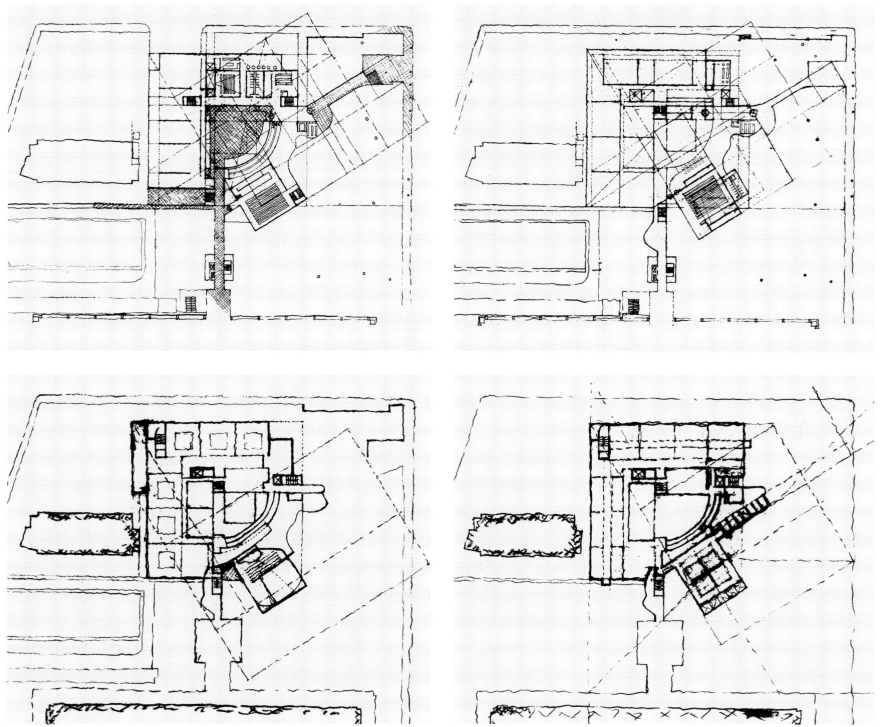

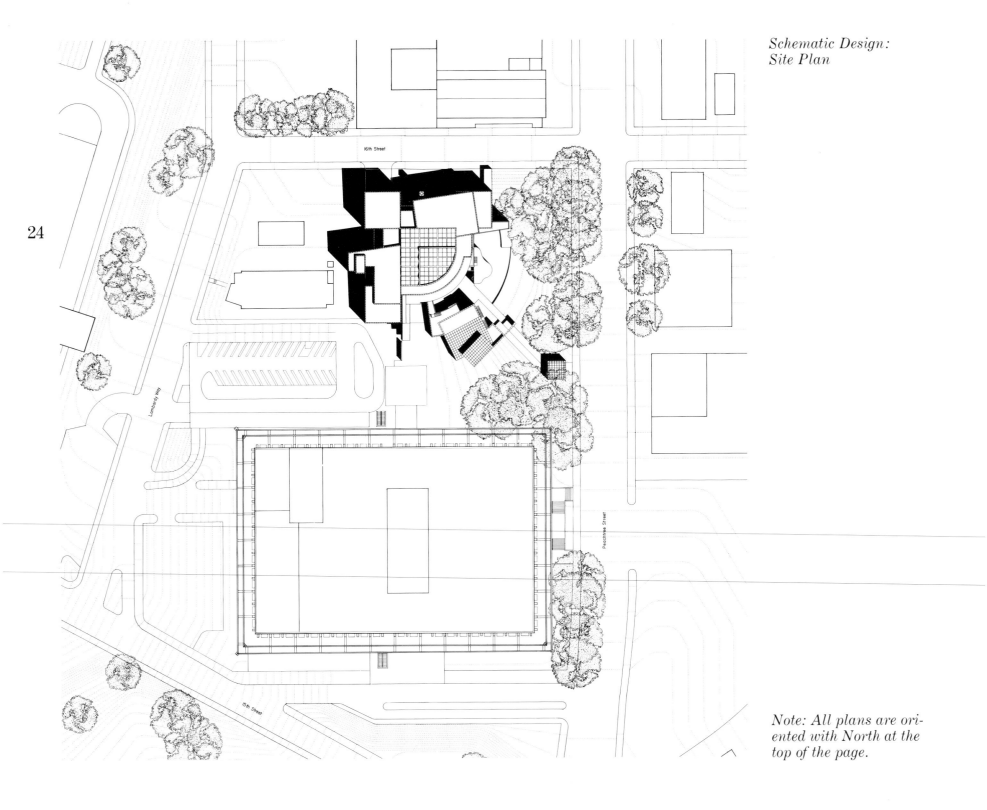

24

16th Street

Lombardy Way

Peachtree Street

15th Street

Note: All plans are ori-
ented with North at the
top of the page.

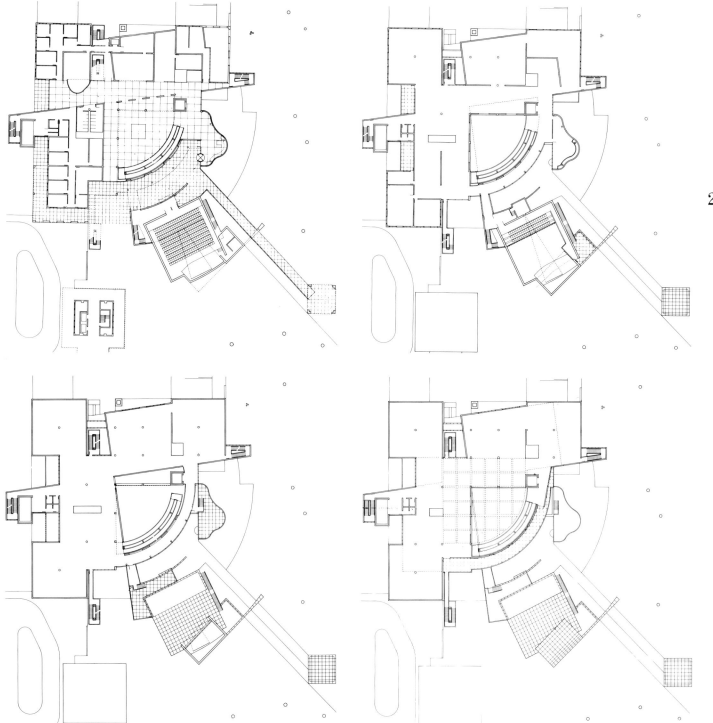

25

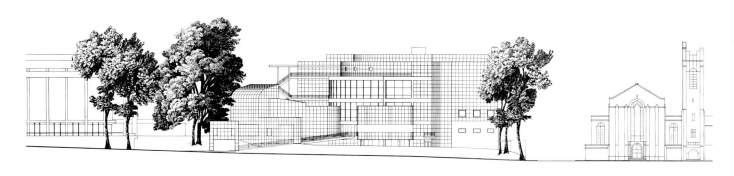

Schematic Design:
East Elevation from
Peachtree Street
South Elevation
West Elevation
North Elevation

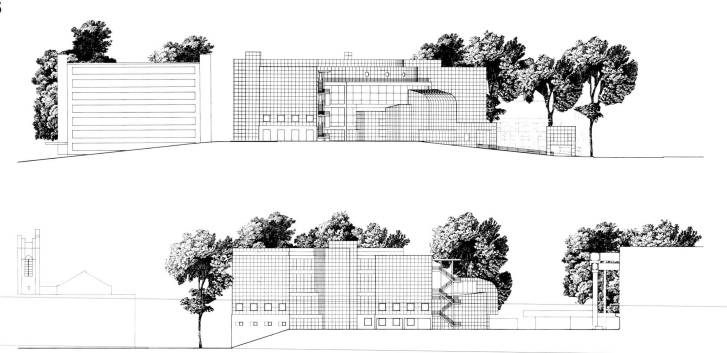

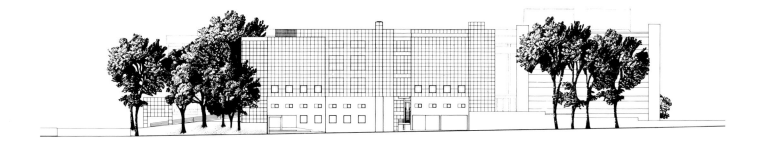

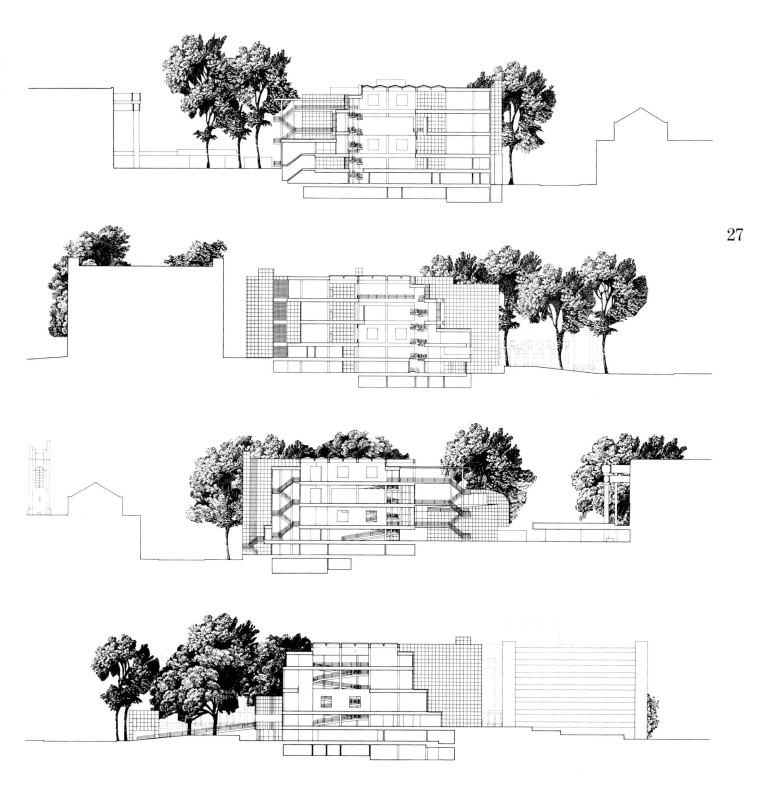

Schematic Design:
Section through Atrium
looking West
Section through Atrium
looking North
Section through West
Galleries looking East
Section through North
Galleries looking South

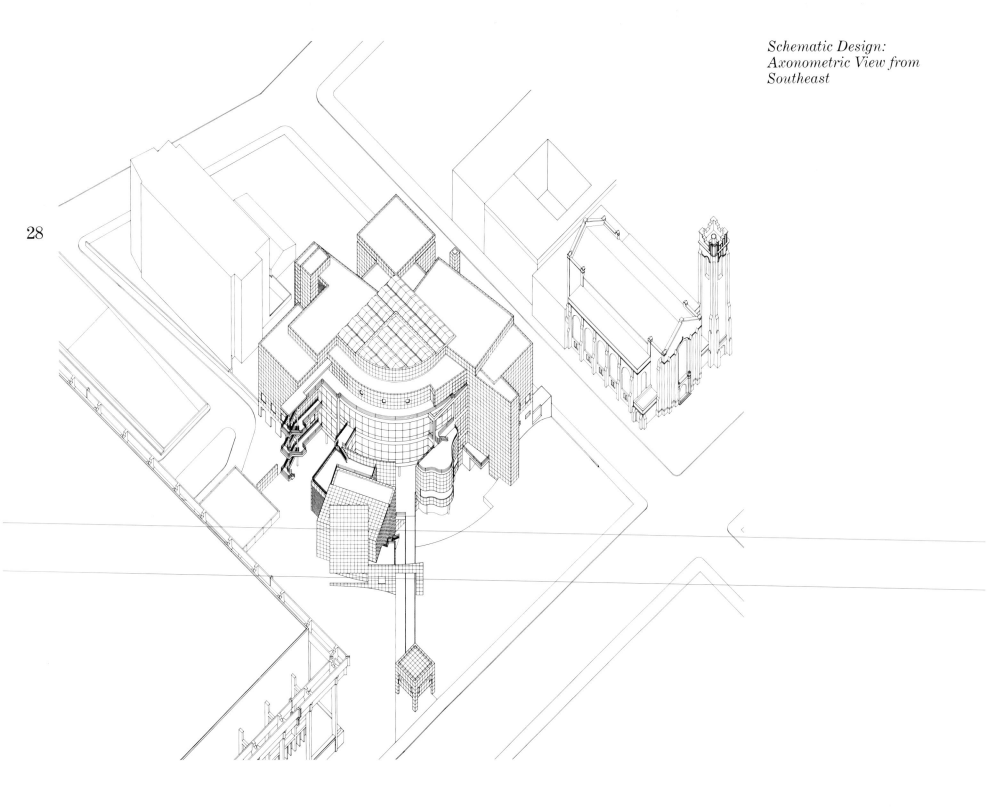

Schematic Design:
Axonometric View from
Southeast

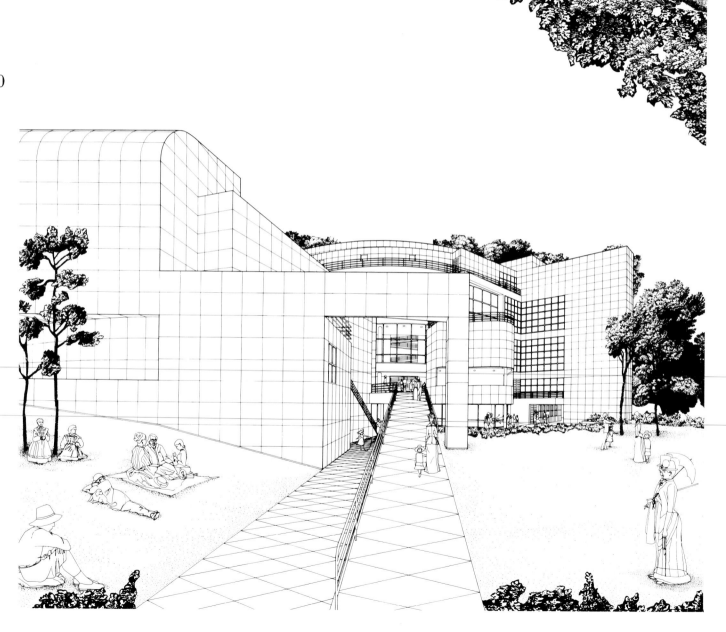

*Schematic Design:
Perspective View from
Peachtree Street*

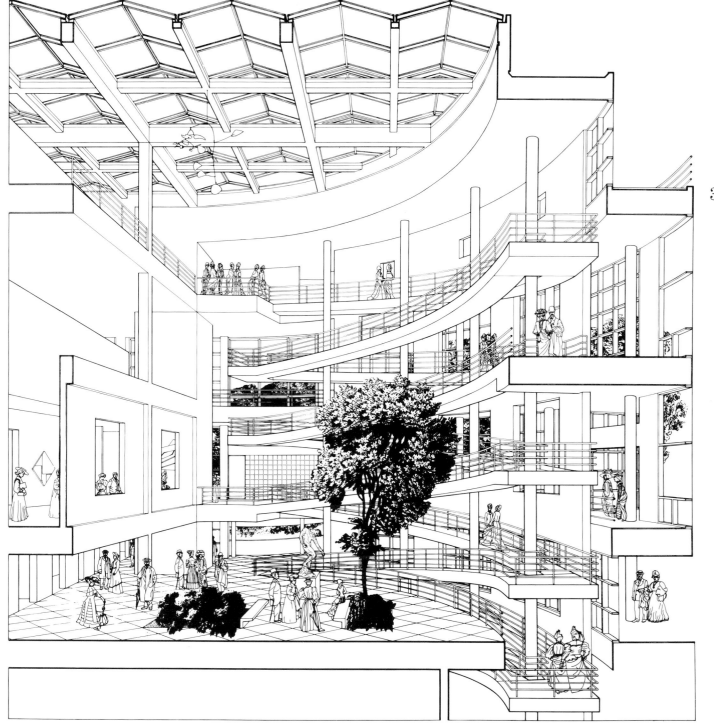

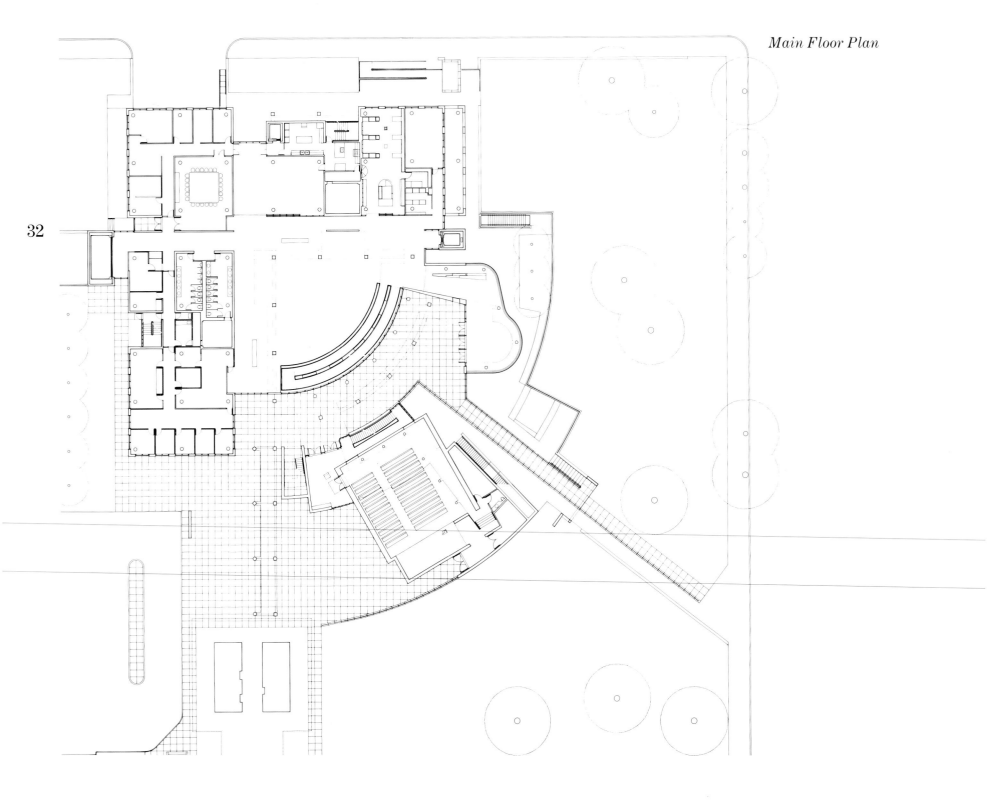

32

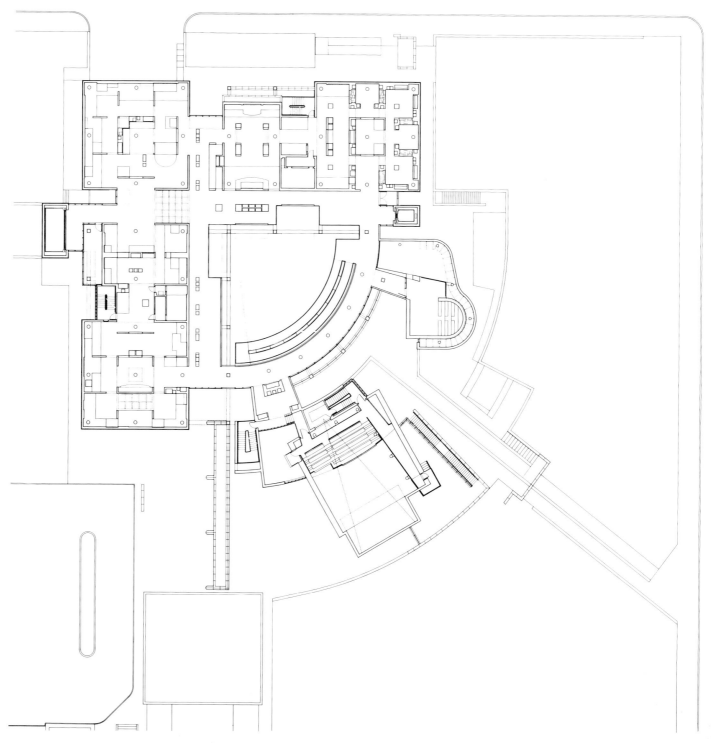

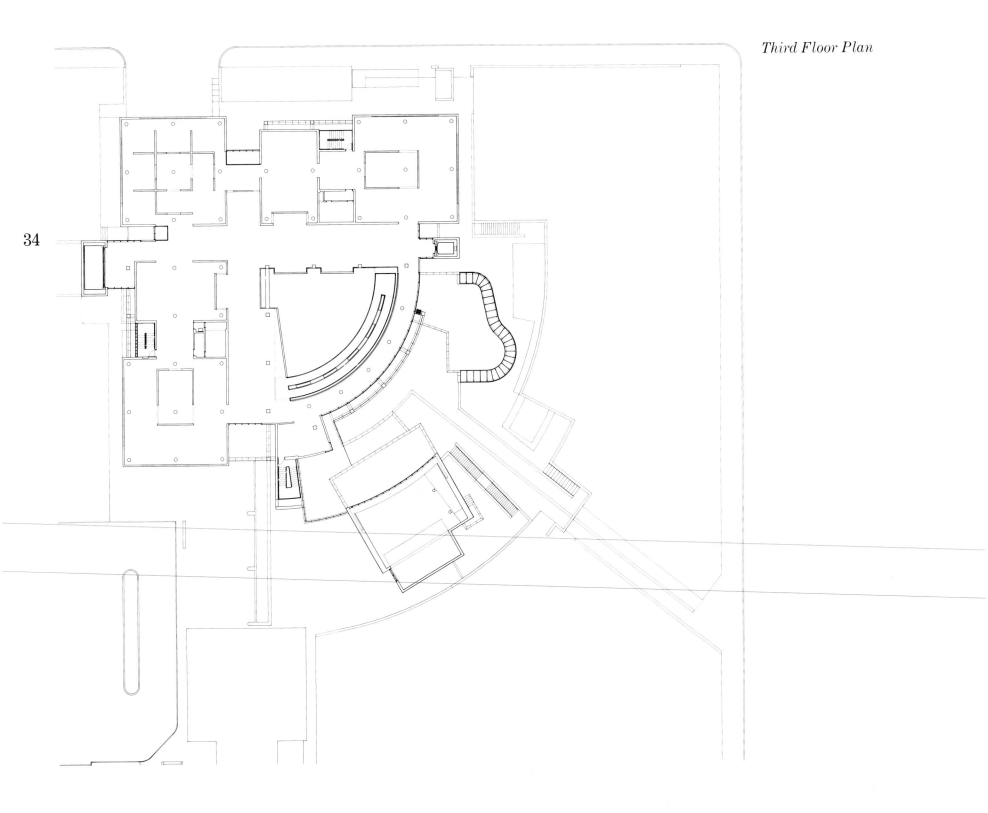

34

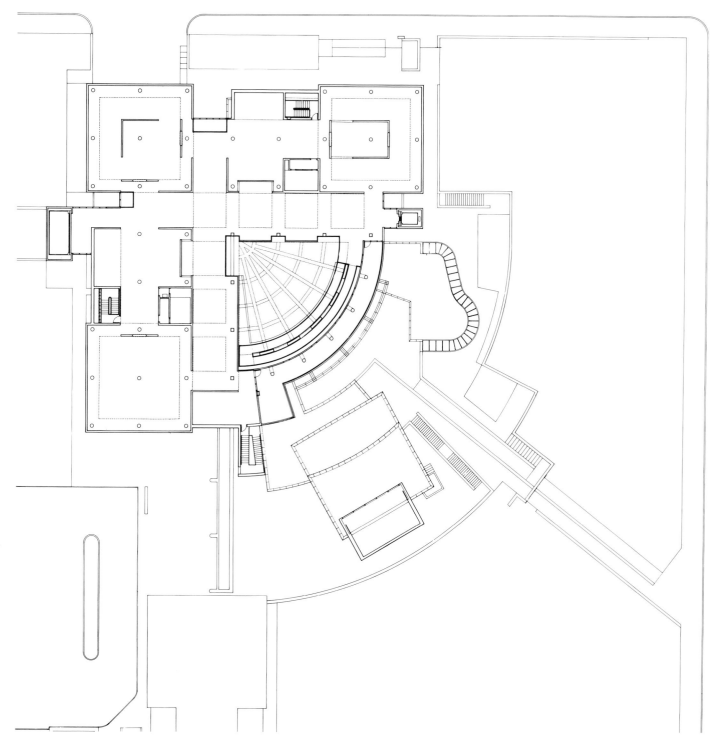

36

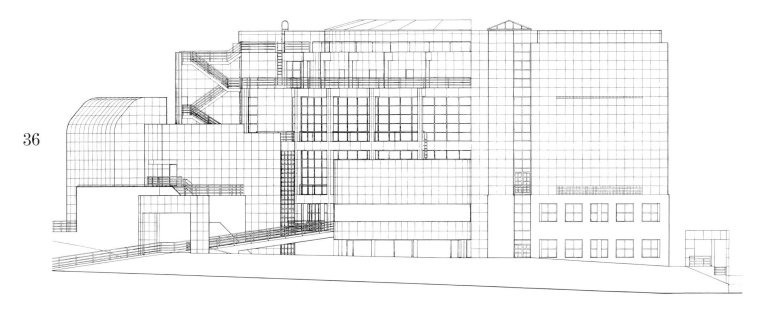

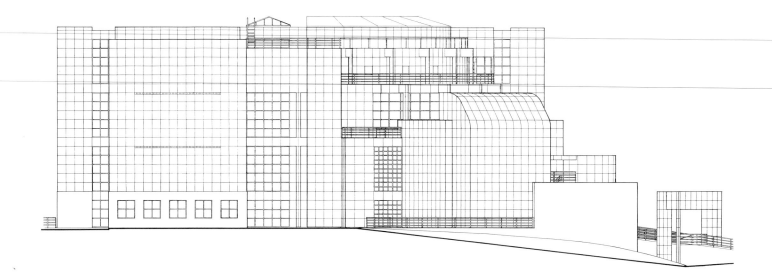

Section through Atrium
and Auditorium

The principal elements
of the museum are visi-
ble from the main entry
on Peachtree Street.

One proceeds through
the entry portal, up the
ramp, along the archi-
tectural promenade, be-
tween the auditorium at
left and the curvilinear
entry at right, to the
glazed atrium that
serves the enclosed gal-
lery spaces beyond.

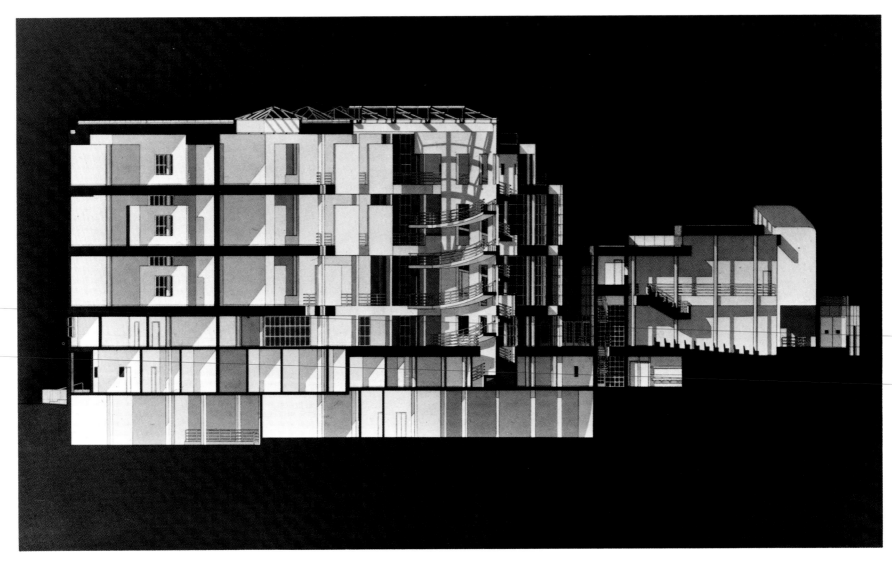

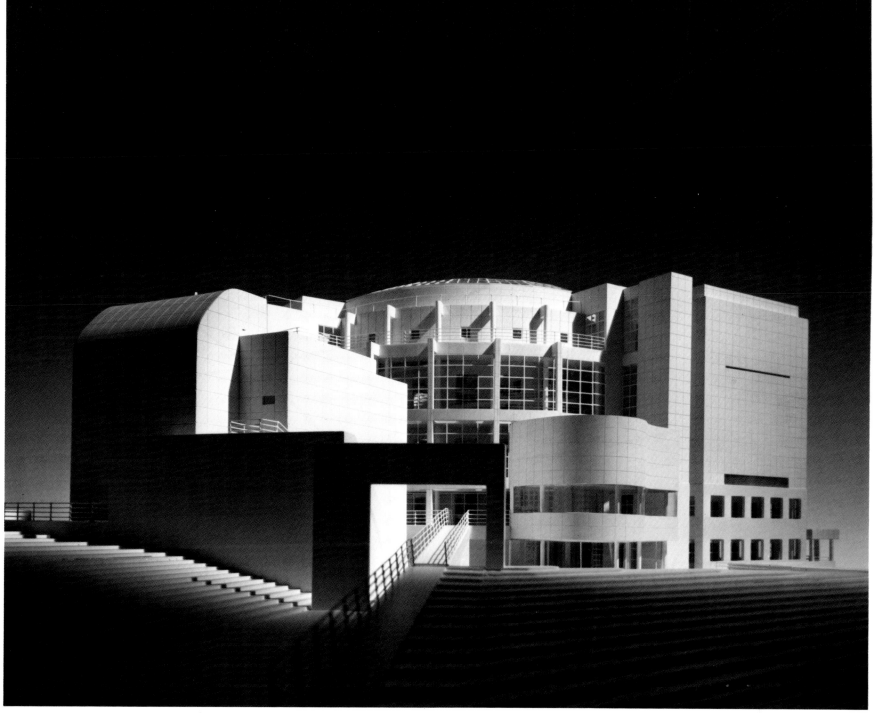

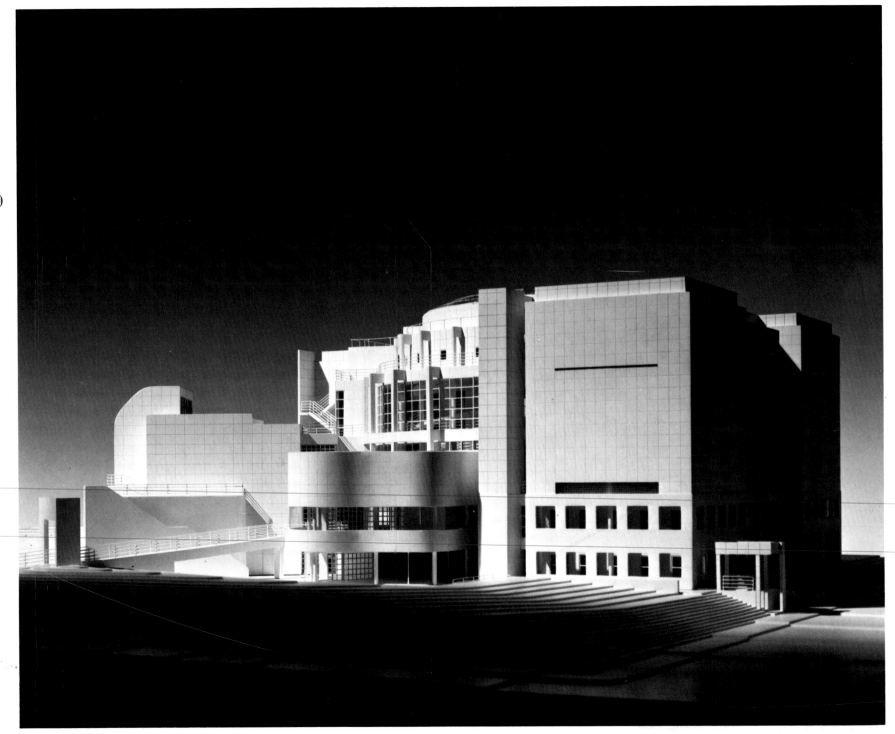

An oblique view of the museum emphasizes its relationship to the existing context. The side of the museum facing the Memorial Arts Building and Peachtree Street is open and fragmented, inviting entry. The 16th Street side is essentially closed and planar.

Seen from above, the geometric quality in the composition of the various elements is evident. The formal relationship between the square and the circle and their components is revealed.

41

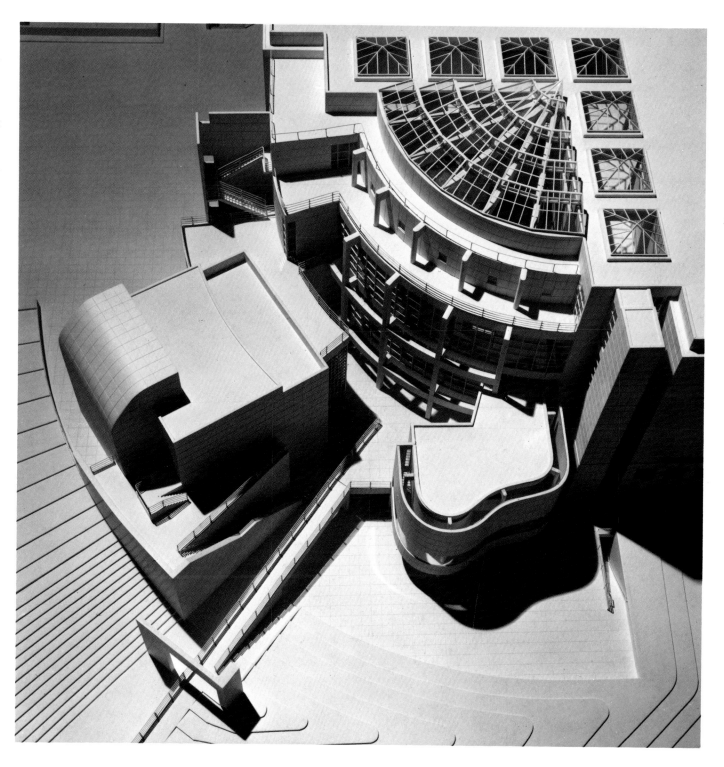

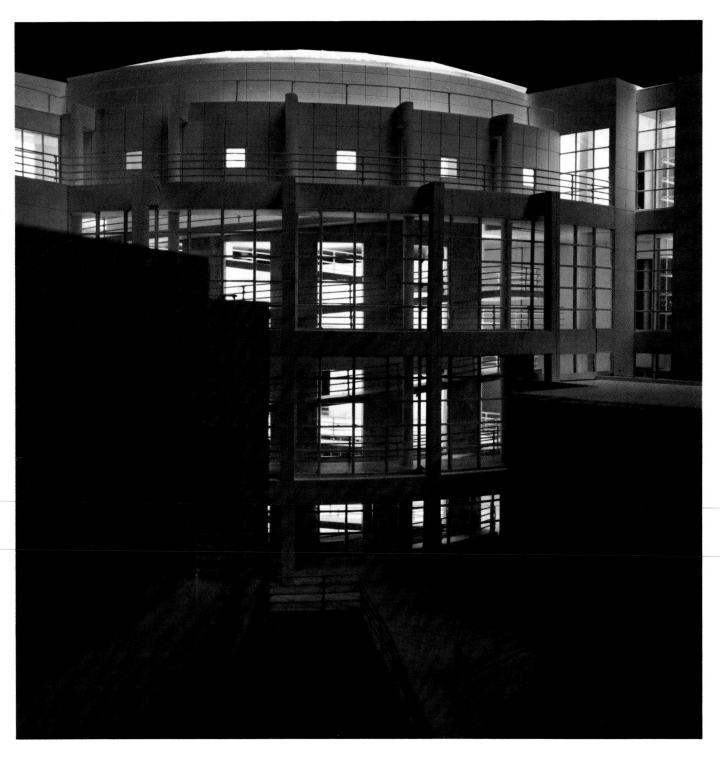

Through the glazed exterior wall one views the illuminated atrium and the curved ramp along its edge that provides circulation to the adjacent gallery spaces.

As viewed from the Memorial Arts Building the transparent grid is revealed through the slot between the closed mass of the gallery at left and the emergency stair at right, indicating access to the entry path along the curved edge of the glazed atrium.

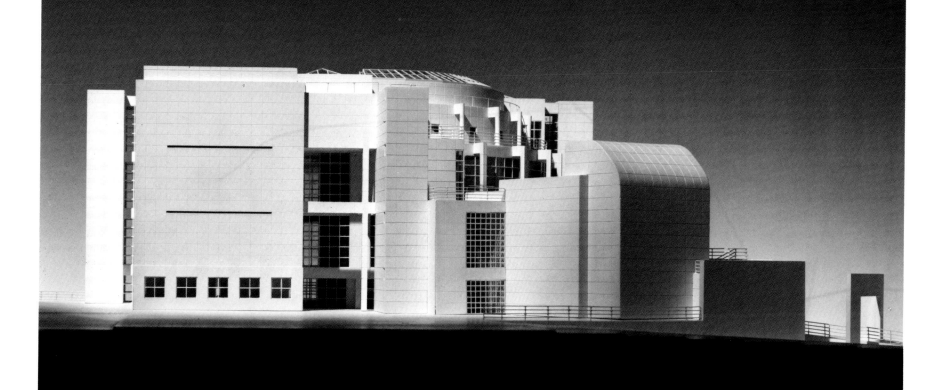

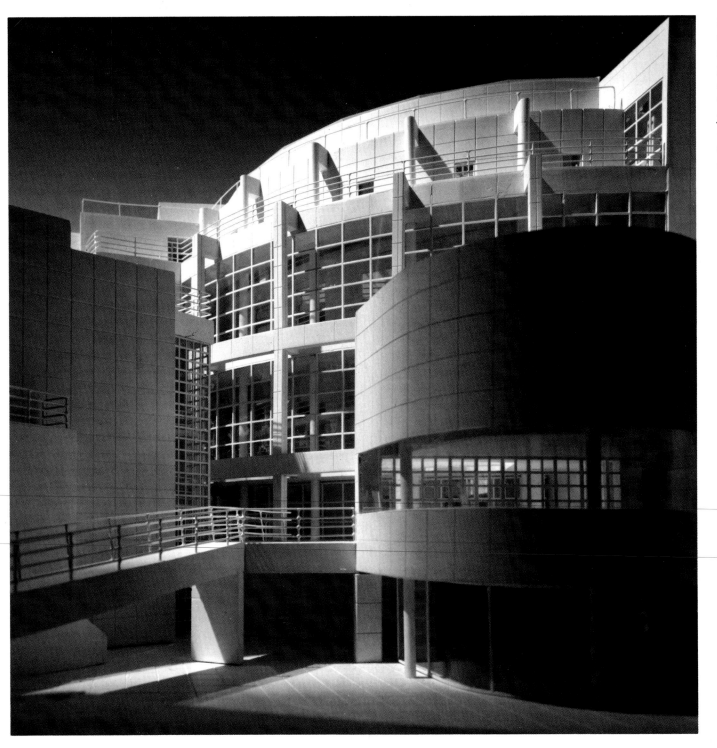

44

A Modern Synthesis

Anthony Ames

The architecture of the new High Museum of Art in Atlanta expresses a spirit of unabashed optimism. Bold and powerful, the building confidently reaffirms the positive qualities of a modernist architecture and continues an exploration and redefinition of the potential of its forms and ideology. This is not a building that takes a timid or superficial approach, simply reverting to an architecture of the past, but one that recognizes architectural history as a wonderful source through which design can be informed, enriched and transformed. The museum conveys an acknowledgement of architectural precedent but also, through reinterpretation and combination, it succeeds in creating a truly remarkable new synthesis of form.

As in all of Meier's buildings, there exist at the High many underlying and unmistakable references to Le Corbusier[1] (fig. 1). Indeed, even here Meier employs Le Corbusier's five points of a new architecture:[2] the use of pilotis (columns), the flat roof or roof garden, the free plan, the free facade and the ribbon window (fig. 2). Allusions to Le Corbusier's aesthetic are evident: the pipe rails, the nautical forms, the smooth, taut, white skin stretched over the frame of the building. Although these are characteristic of an earlier modernist expression—that of Le Corbusier's villas of the 1920s[3]—they have been adapted and given new life and meaning by Meier. The language is similar, but the vocabulary has been greatly enlarged and enriched, and the syntax has become much more complex.

Meier has elaborated on Le Corbusier's definition of architecture as being "the masterly, correct and magnificent play of masses brought together in light,"[4] for his buildings show a more sophisticated use of spatial development and the effect of light on space than did Le Corbusier's. By drawing upon advances in the technics of building, Meier is able to create a drama only imagined by his predecessors, who had available to them a much more primitive technology. In the Paris of the twenties, technology could not keep pace with the modernist ideology: an industry did not yet exist that could successfully produce the architecture whose aesthetic relied so heavily on the image of and the anticipation of the new machine age. There was, for example, no thin, light skin that could be stretched taut across the

45

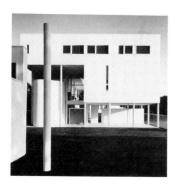

1. House in Old Westbury, Old Westbury, New York, Richard Meier (1969–1971)

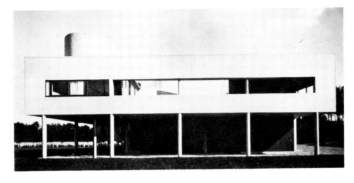

3. Villa Savoye, Poissy, France, Le Corbusier (1929–1931)

4. Staircase, Arts Club of Chicago, Chicago, Illinois, Mies van der Rohe (1948–1951)

46

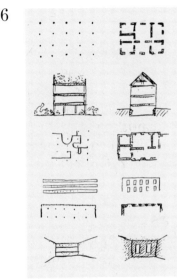

2. The Five Points of a New Architecture, Le Corbusier

frame of a building to achieve the look that modern architects of the age were striving for. At the Villa Savoye (fig. 3) Le Corbusier covered concrete block with stucco in order to achieve this effect—hardly an honest expression of structure, but temporarily it created the required visual effect. Meier, however, has the advantage of new technology and he has developed a metal panel system that can at last provide the architect with a skin that in essence can be stretched over a frame in a continuous, uninterrupted fashion. While Meier certainly did not invent the metal panel, he has through research and investigation virtually rediscovered and subsequently reintroduced a method of enclosure that had been all but abandoned and forgotten. This "new" skin wraps corners and even becomes the roof of the building.

Although the most apparent references can be attributed to Le Corbusier, the High is much more than a simple restatement of his work; the building also integrates a number of other influences. The detailing probably draws much more on Mies van der Rohe,[5] for it was through Mies—who said that "God is in the details"[6]—that Meier increased his

awareness of the importance of architectural detailing. In the High Museum of Art the level of detailing remains consistent and refined at every level, from the largest to the smallest scale (fig. 4).

In the interior of the building, where Meier employs a central vertical space with a ramp, the immediate recognizable reference is to Wright's[7] Guggenheim Museum (fig. 5) (although here again a reference to Le Corbusier must be acknowledged in the incipient form of the ramp at Savoye. The purpose of the ramp in the Guggenheim is meant to be its value as a circulation device that allows the visitor to experience the central space; it ends up, however, essentially competing with the art on display as the viewer is always torn between the exhibition on one (curved) wall and the drama of the view of the enclosed space on the other edge. Furthermore, the notion of displaying general rectangular works of art in a low-ceilinged, sloped space seems somewhat misdirected. Meier successfully avoids any such conflict at the High as the ramped, voided quadrant serves *only* as a means of circulation in relation to the observation of the central space; the viewing of art is

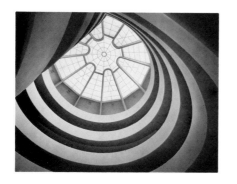

5. *Atrium, The Solomon R. Guggenheim Museum, New York, Frank Lloyd Wright (1943–1959)*

reserved for the more ideal setting of regular rectangular gallery spaces that are removed from but adjacent to the domain of the skylit vertical space.

The High Museum's auditorium further reinforces the notion of the building as a synthesis of architectural form, for here, as in his projects at New Harmony[8] and Hartford[9], Meier draws on the work of another master—Alvar Aalto[10] Both the sectional quality of the auditorium (fig. 6) and the use of indirect light to create a dramatic effect are informed by Aalto. But even more pertinent to Aalto is Meier's masterful solution for the entry piece. Just as Aalto played an undulating or whimsical line against a datum, in plan Meier contrasts the curvilinear entry piece against the geometrical order of the composition.

Again Le Corbusier can be identified as a significant influence, for in elevation the entry pavilion can be read as an undulating Villa Savoye.[11] But here, Meier further emphasizes the independence of the curtain wall by introducing a narrow skylight located between its curvilinear edge and the roof plane.

The implication thus far has been that the High employs a referential architecture based only upon a modern precedent, but nothing could be further from the truth. Although Meier's architecture refrains from the precious and banal tricks of applied historicism, his buildings certainly manifest an awareness of a pre-modern architecture. In the High, as well as in Meier's contemporaneous new museum in Frankfurt, West Germany, an architecture of classicism is indeed evident. In the plan of both museums the prominence of center and symmetry, based on the square and its division into four quadrants, shows the importance of classical themes (fig. 7). But more specifically, Meier's reference to the museums of Von Klenze[12] in Munich (fig. 8) and his contemporary Schinkel[13] in Berlin (fig. 9) in his use of a skylit central space surrounded by idealized, regularized exhibition space, can be seen as a further development and elaboration of museum typology. In elevation and section the horizontal division of the building and the setting of the building on a "rusticated" base (although the module remains the same, there is a shift in material) create a *piano nobile*, the level on which the public spaces begin and below which the

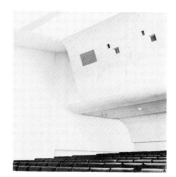

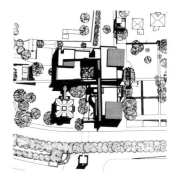

6. *Auditorium, Cultural Center, Wolfsburg, Germany, Alvar Aalto (1958–1963)*

7. *Site Plan, Museum Für Kunsthandwerk, Frankfurt, Germany, Richard Meier and Partners (1980–)*

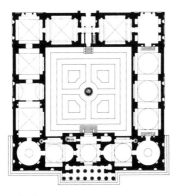

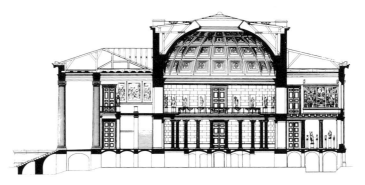

8. Floor Plan, The Glyptothek, Munich, Germany, Leo von Klenze (1816–1830)

9. Transverse Section, The Altes Museum, Berlin, Germany, Karl Friedrich Schinkel (1923–1930)

48 more mundane aspects of the program are accommodated. This clearly calls into use an ordering system based on a classical architectural tradition.

Thus the new High Museum of Art is a building that refers to architectural precedent and history not through a bland regurgitation of ersatz fragments and applied decoration, but more thoughtfully through a reinterpretation of and elaboration upon ideas dealing with form, space and order—the essence of architecture. Meier's work at the High can be read as a successful blending of or mediation between modern and pre-modern architecture. It recognizes and transforms the most positive and germane qualities of each, synthesizing them into a new, optimistic and certainly more enlightened architecture that boldly symbolizes a faith and confidence in its own existence.

Notes:

1. Charles-Edouard Jeanneret (1887-1965)
2. "Les 5 Points D'un Architecture Nouvelle" Le Corbusier and Pierre Jeanneret, *Oeuvre Complète, Volume* 1, 1910-1929 (Geneva: W. Boesiger and O. Stonorov, 1929) p. 128
3. *Oeuvre Complete, Volume* 1, 1910-1929, p. 189
4. "L'architecture est le jeu savant, correct et magnifique des volumes assemblès la lumière." Le Corbusier, *Vers Une Architecture* (Paris: Editions Crès, 1923) p. 16
5. Ludwig Mies van der Rohe (1886-1969)
6. Peter Blake, *The Master Builders* (New York: Alfred A. Knopf, 1961) p. 174
7. Frank Lloyd Wright (1867-1959)
8. The Atheneum, New Harmony, Indiana (1975-1979)
9. The Hartford Seminary, Hartford, Connecticut (1978-1981)
10. Alvar Aalto (1898-1976)
11. This form also has a precedent in the early work of Michael Graves, John Hejduk and Meier himself.
See: *Five Architects: Eisenman, Graves, Gwathmey, Hejduk, Meier* (New York: Wittenborn & Co., 1972)
12. Leo von Klenze (1784-1864)
13. Karl Friedrich Schinkel (1781-1841)

Photographic Record of Construction: July 1981 to September 1983

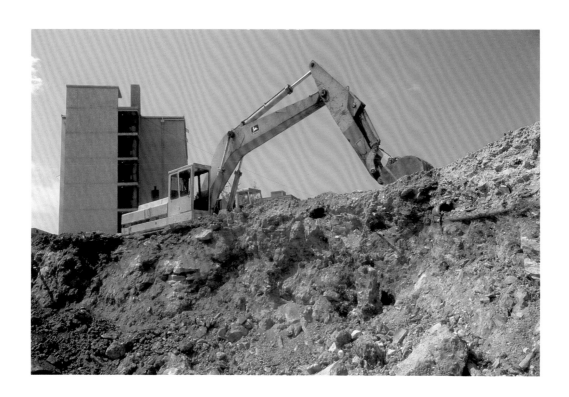

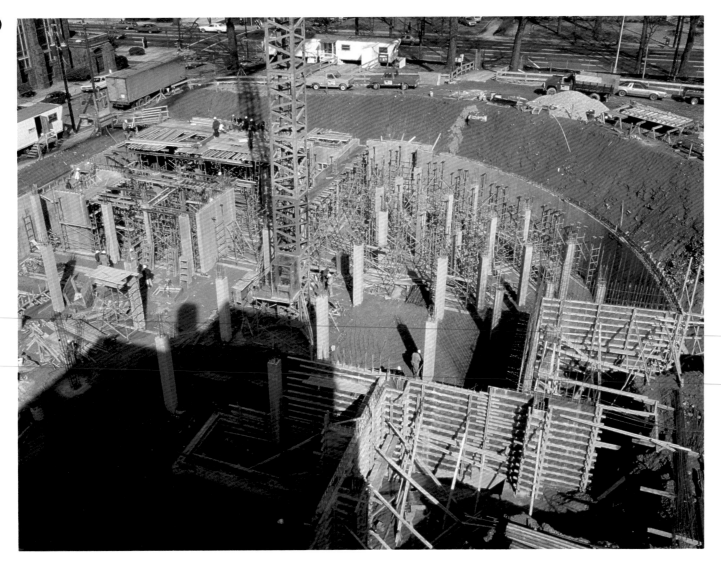

After extensive excavation on the building site, the concrete foundation was laid. The basic building form becomes evident with the erection of the foundation wall and columns.

Due to the repetitive nature of the majority of the floor space, a concrete flat-slab construction was chosen. The plasticity of concrete easily allowed for the forming of the curvilinear entry piece and the curved atrium.

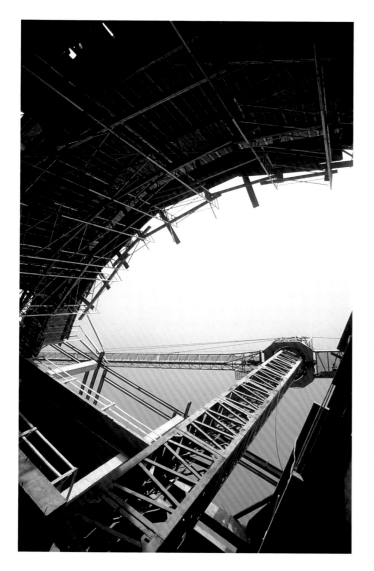

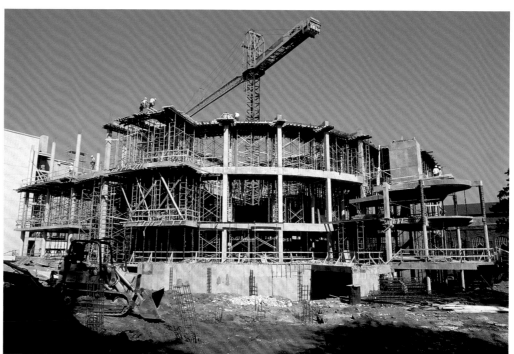

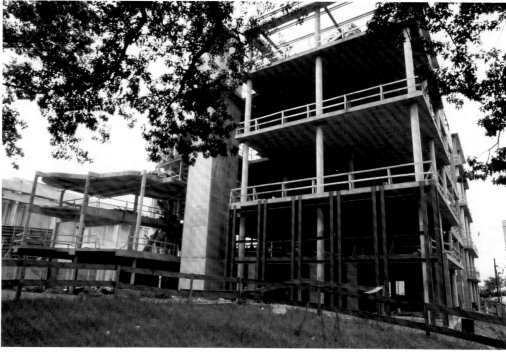

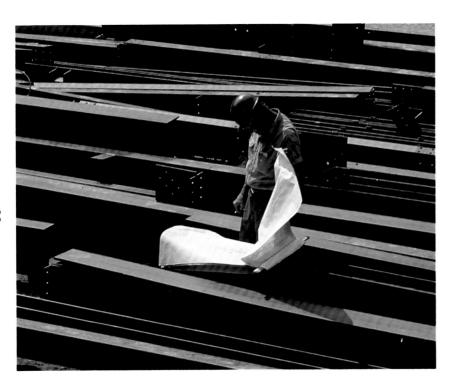

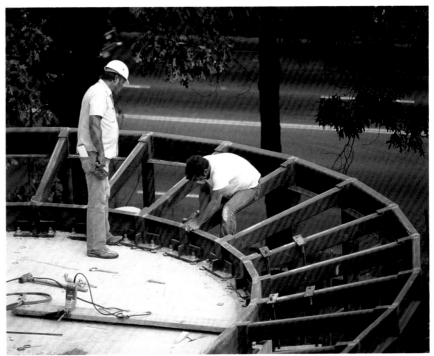

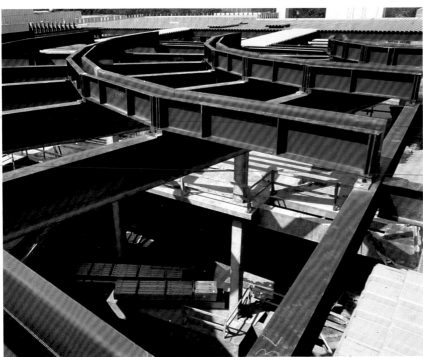

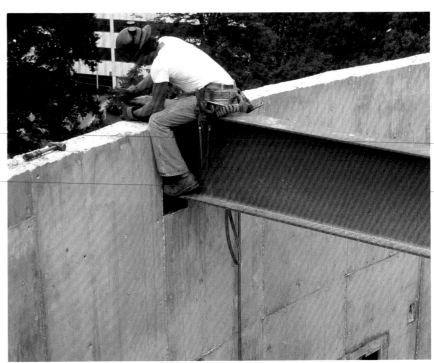

The structural steel framing elements were erected after the concrete work was basically completed.

Steel's lightness and its ability to effectively span long distances made it the most suitable material for components such as the skylit atrium, the auditorim and portions of the entry pavillion.

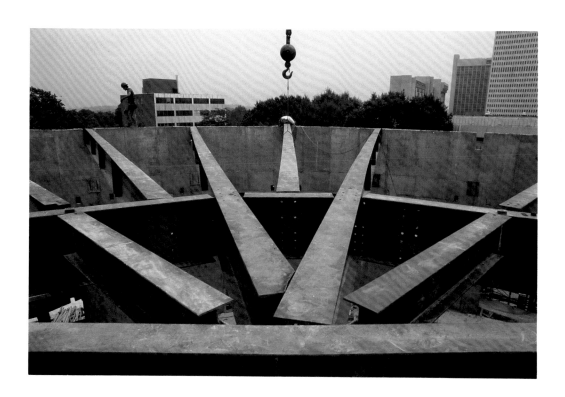

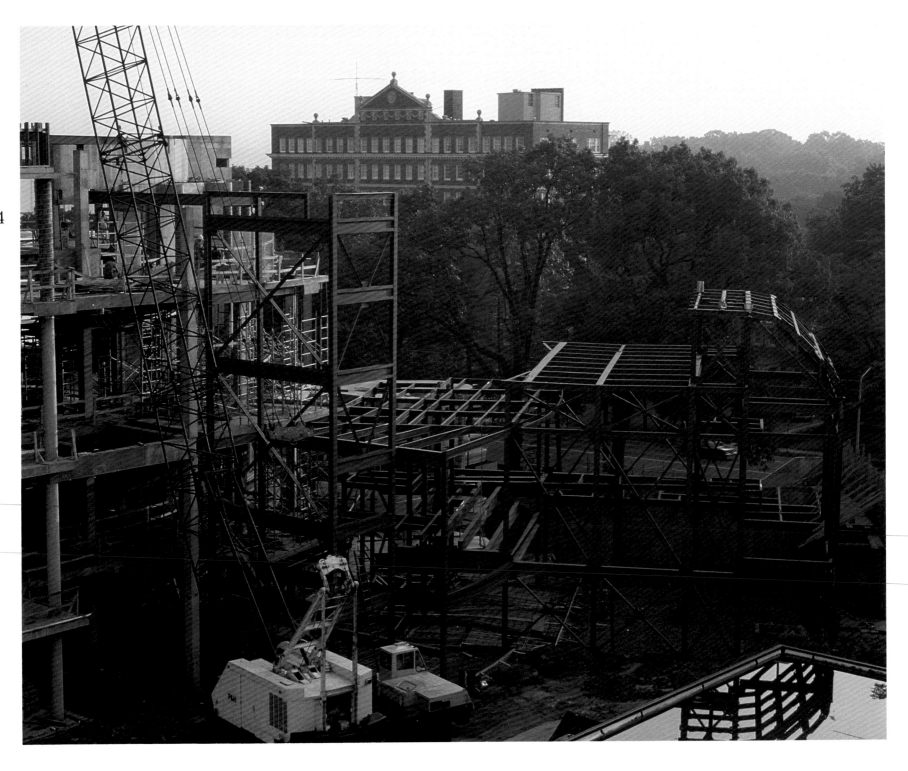

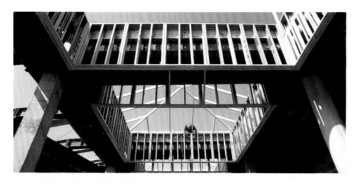

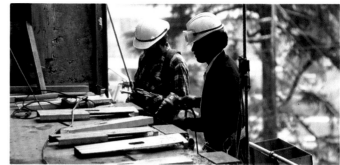

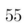

Once the structural components were in place, the building was prepared for the application of the porcelain-enamelled steel panels. A subframe of steel girts that reflected the basic module of the panel grid was applied to the structural frame.

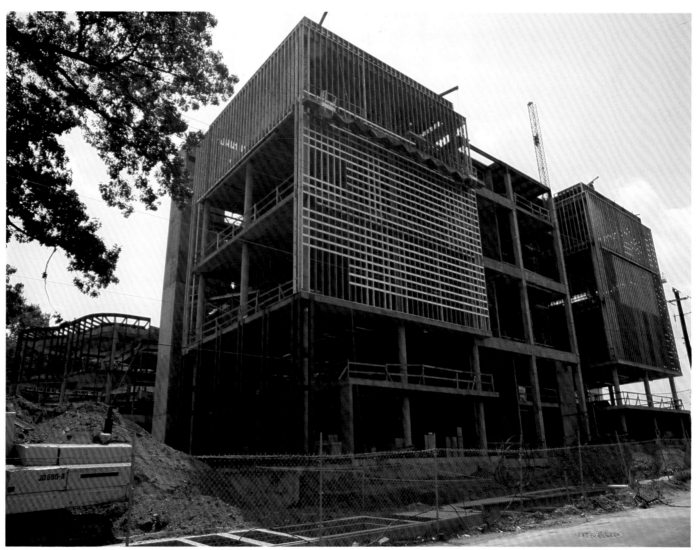

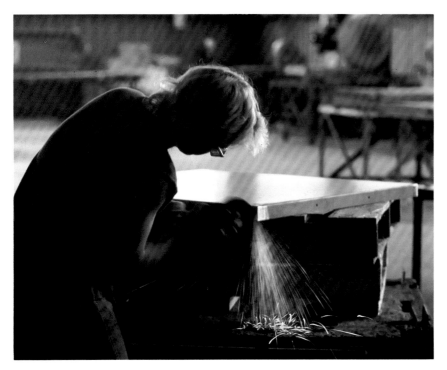
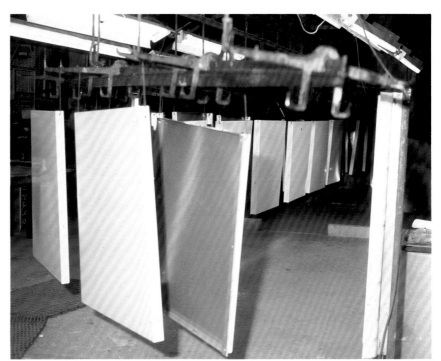

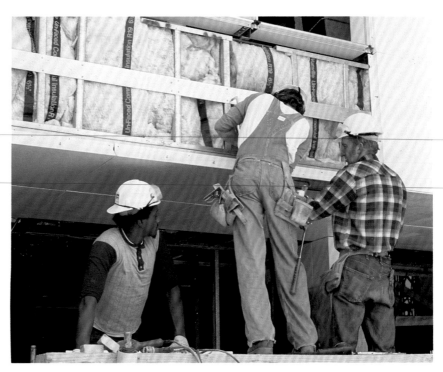

Because a large part of the building grid was repetitive and systematic, it was possible to prefabricate the porcelain panels in a factory located off-site.

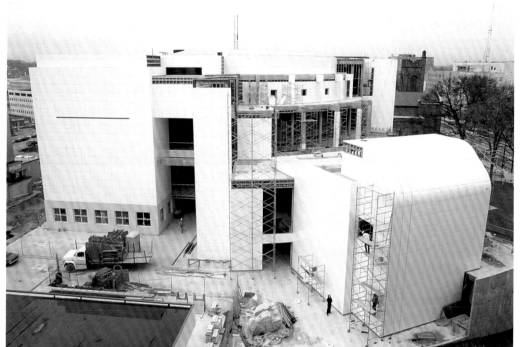

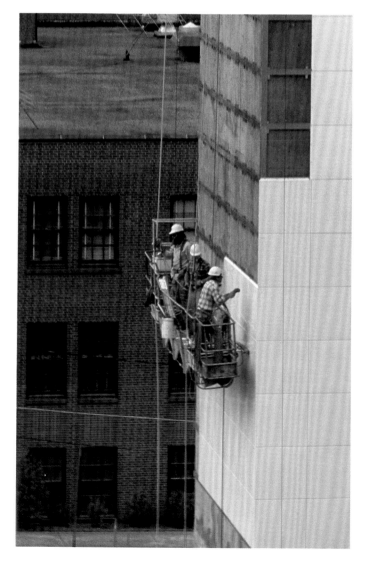

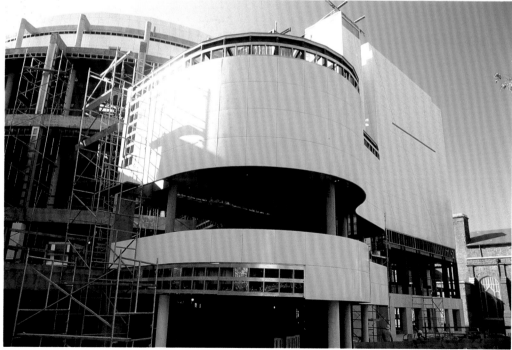

An aluminum-frame window system was employed for the individualized glazed openings, as well as for the larger expanses of glass, as shown here on the curved wall of the atrium.

This gridded window wall system adds another layer of complexity to the geometry within the building's design.

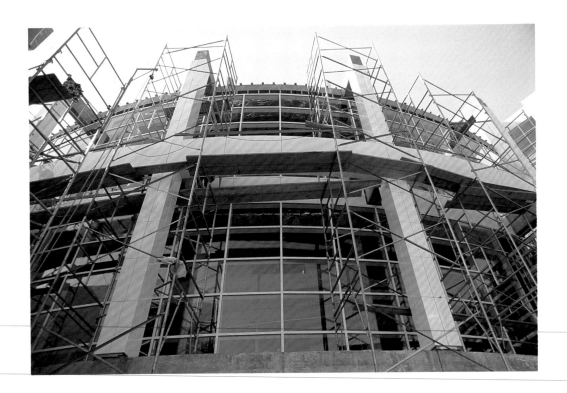

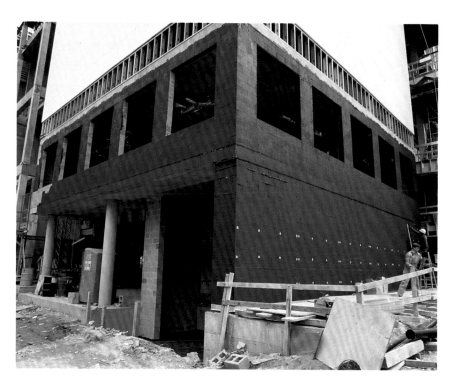

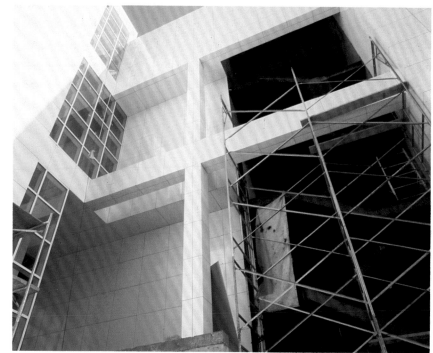

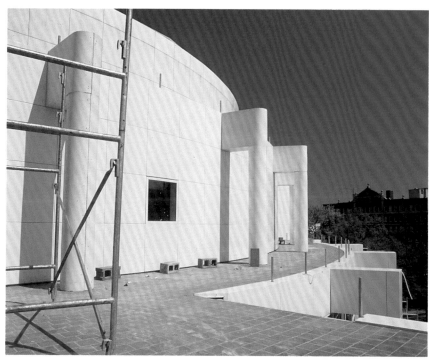

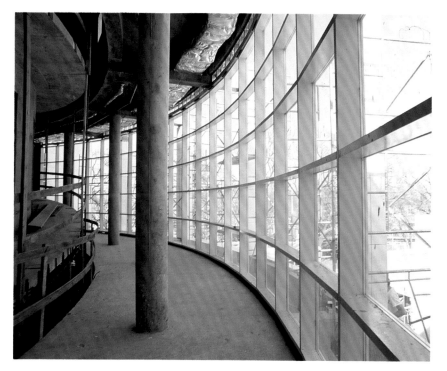

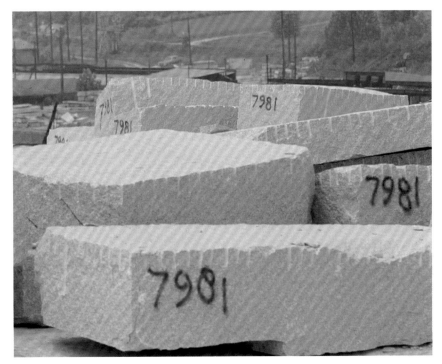

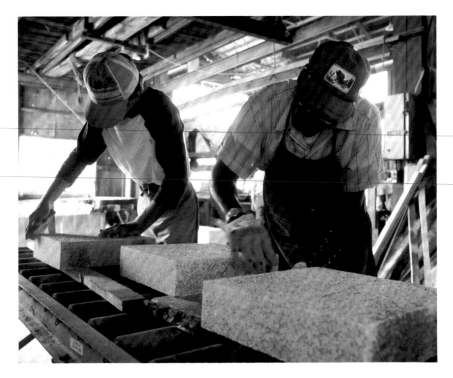

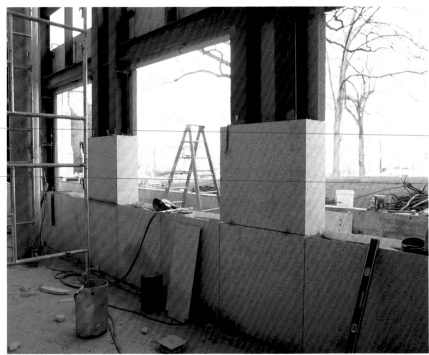

The exterior of the building is essentially completed with the installation of the granite panels. While similar in size and shape to the porcelain panels, their distinctive texture and color create the impression of a podium on which the building rests.

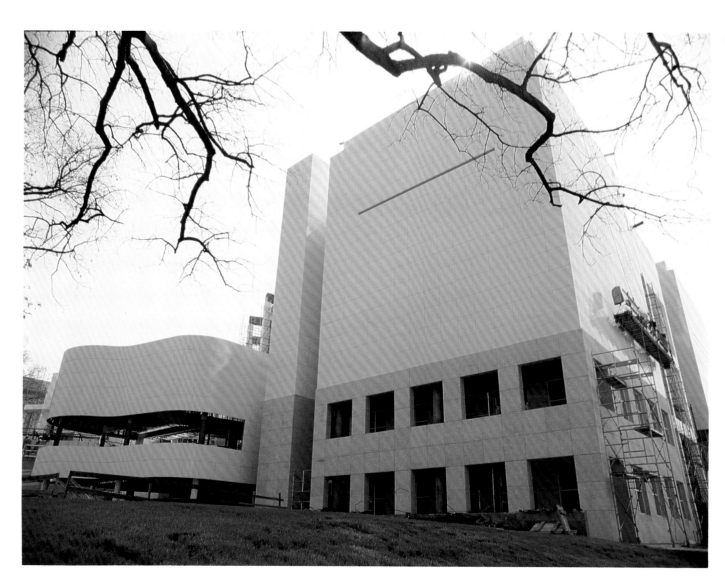

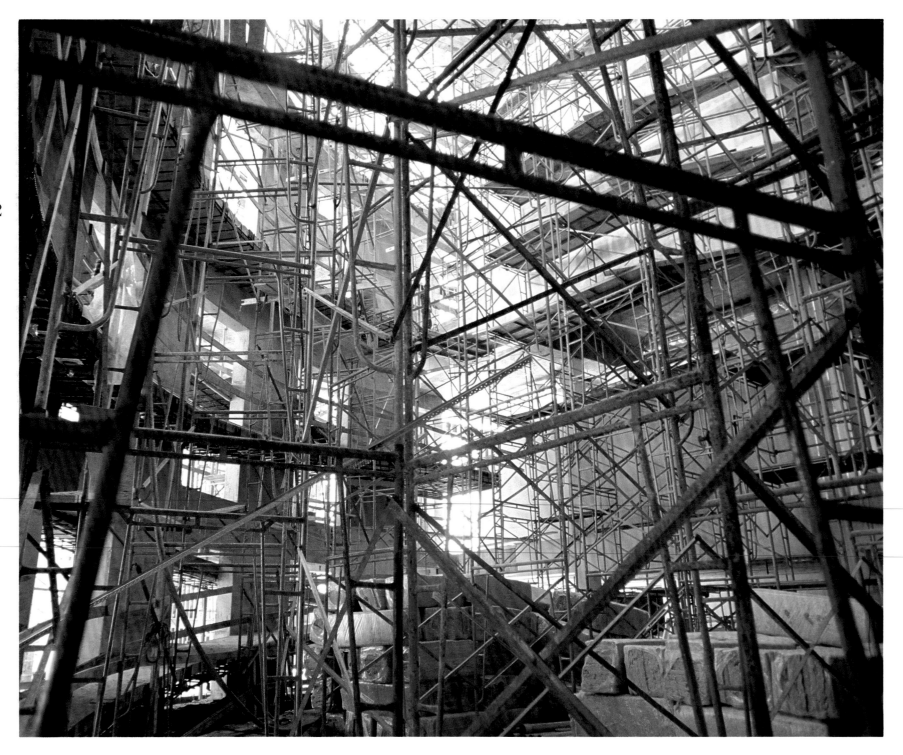

*Once the building en-
closure was complete,
an elaborate scaffolding
system was set up to
facilitate finishing of
the interior space.*

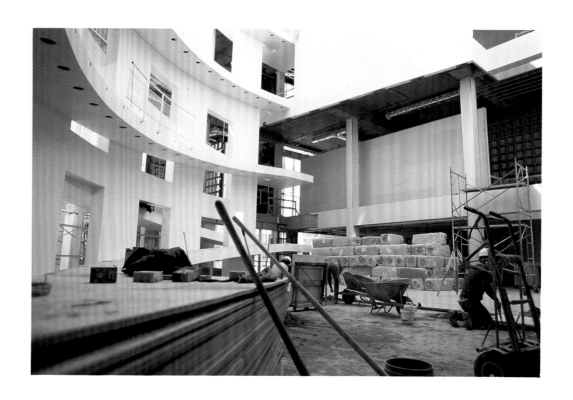

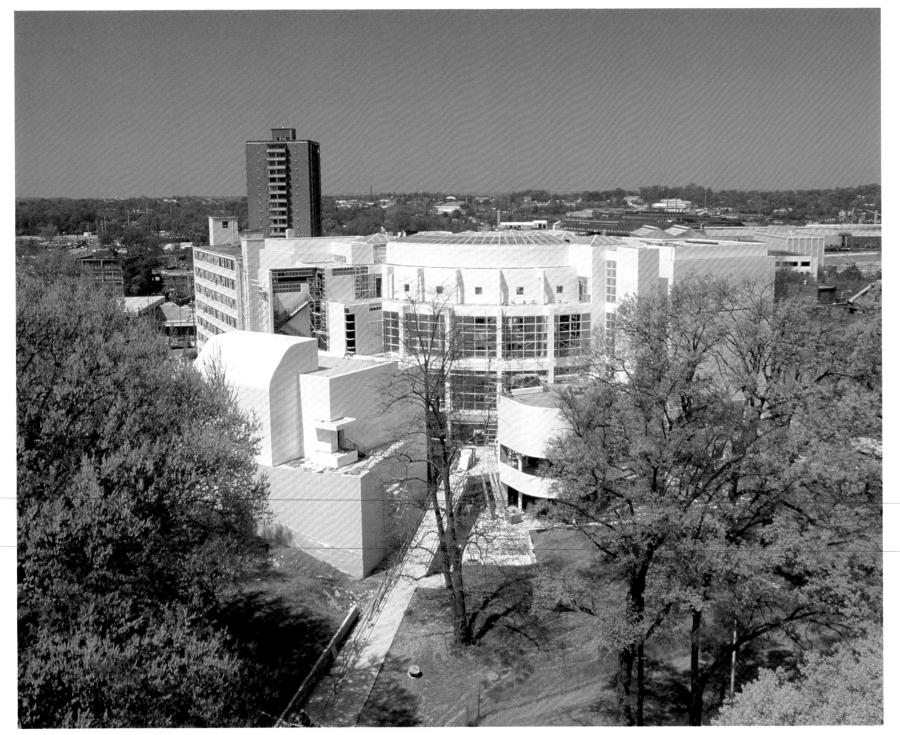

Situated on a two acre site along Atlanta's historic Peachtree Street, the building is entered by an exterior ramp which serves as a symbolic gesture reaching out to the street and the city.

At the end of the ramp is a piano-curved main entry and reception pavilion, from which one passes into the four-story, cylindrical glazed atrium.

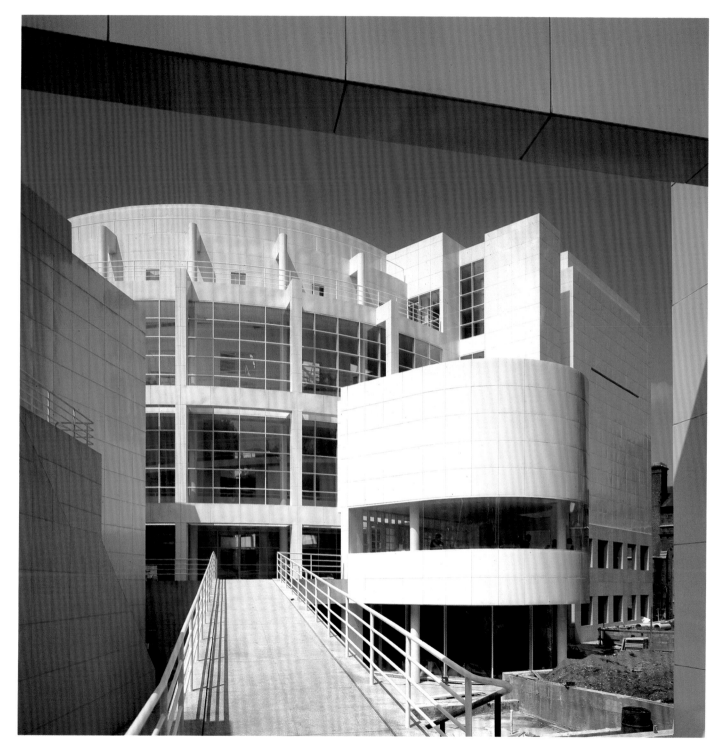

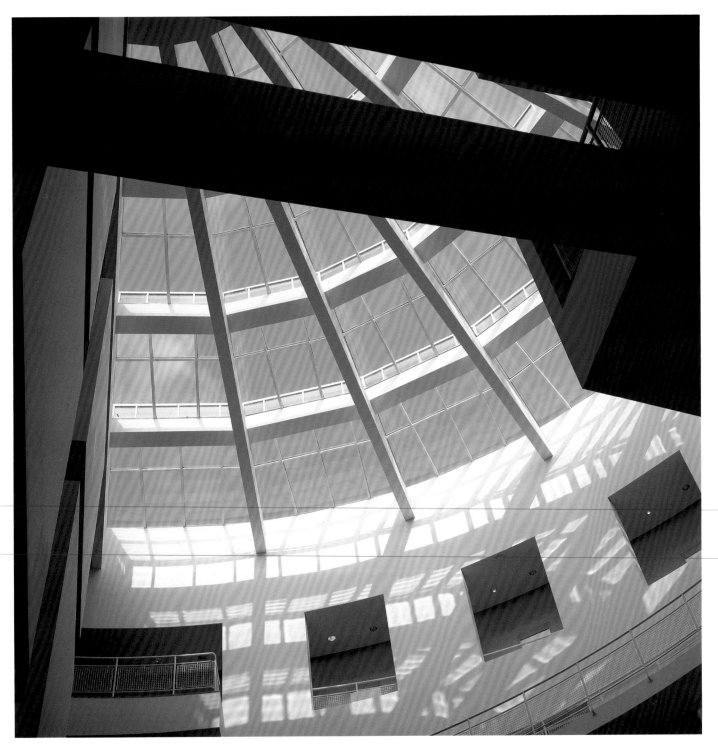

66

Light is a constant theme throughout the building. Apart from its functional aspect, it serves as a symbol of the museum's role as a place of aesthetic illumination and enlightened cultural values.

The building has been described as an elegant, tensile structure, at once rigorously geometric and deeply picturesque. The museum is intended as a contemplative place where the visitor is encouraged to discover the art of architecture as well as the art displayed within.

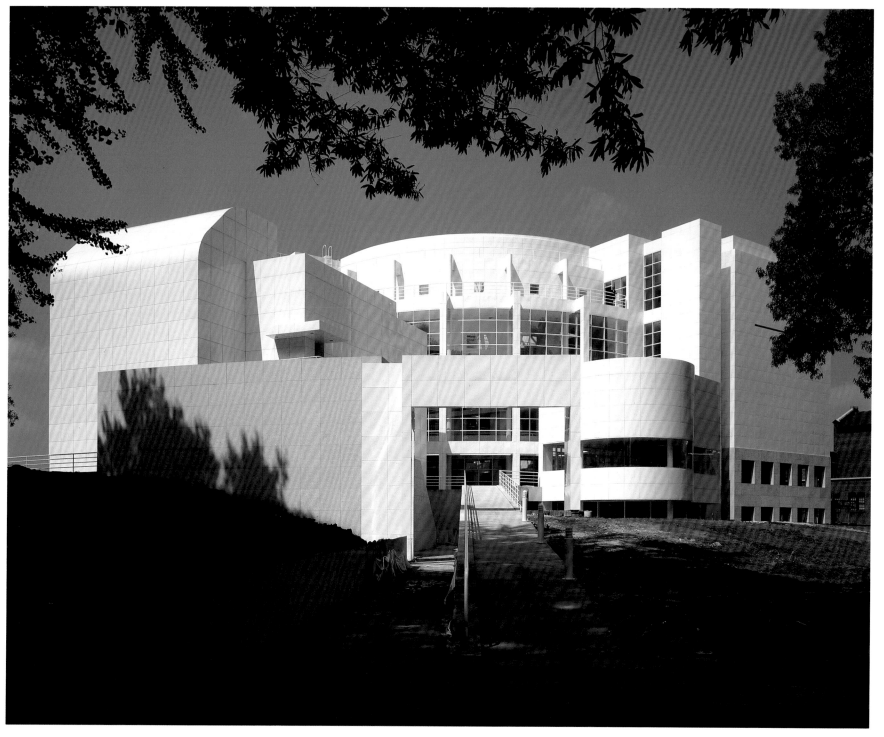

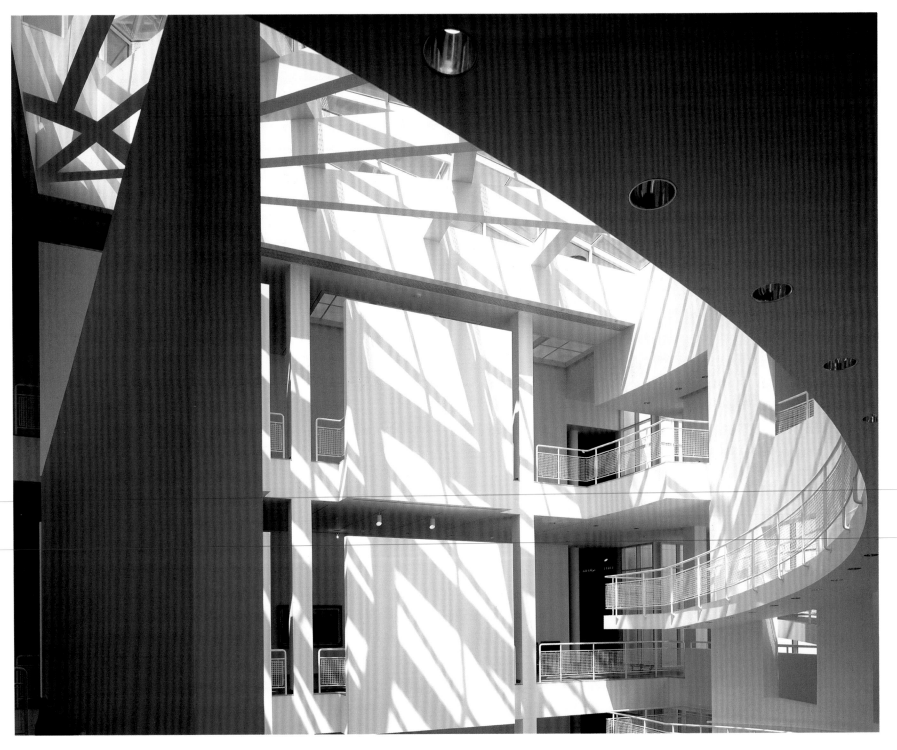

The interior ramp system and the solid atrium walls mediate between the light-filled central space and the art itself, which may be seen and reseen from various levels, angles, and distances as one moves upward.

Spatial variety is created in the galleries by natural light, framed vistas, multiple scales, and glimpses into other galleries, the atrium and the outside.

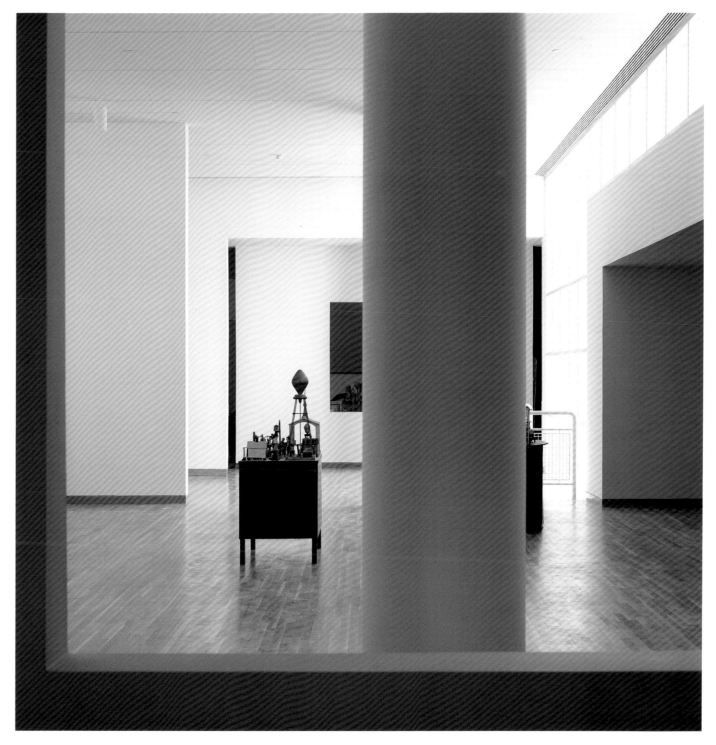

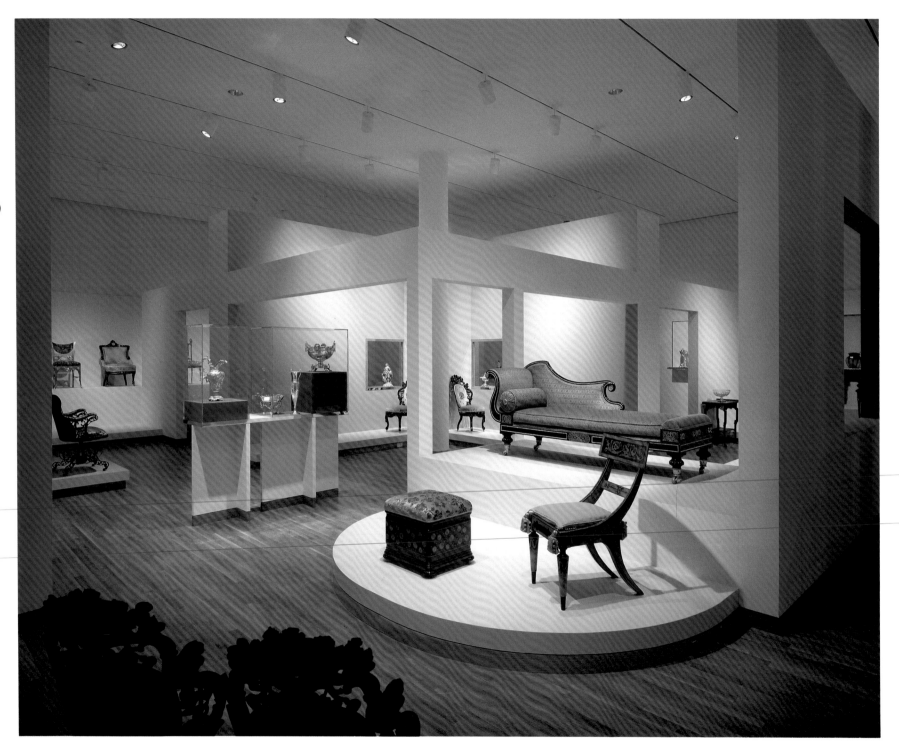

Design of the exhibition spaces was achieved by close collaboration between the architect and the museum's curatorial staff and director, based on the functional requirements of flexible display for the permanent collection and loan exhibitions.

The radiance of the new building's design stands as a symbol for the museum and the city of Atlanta as an evolving cultural force.

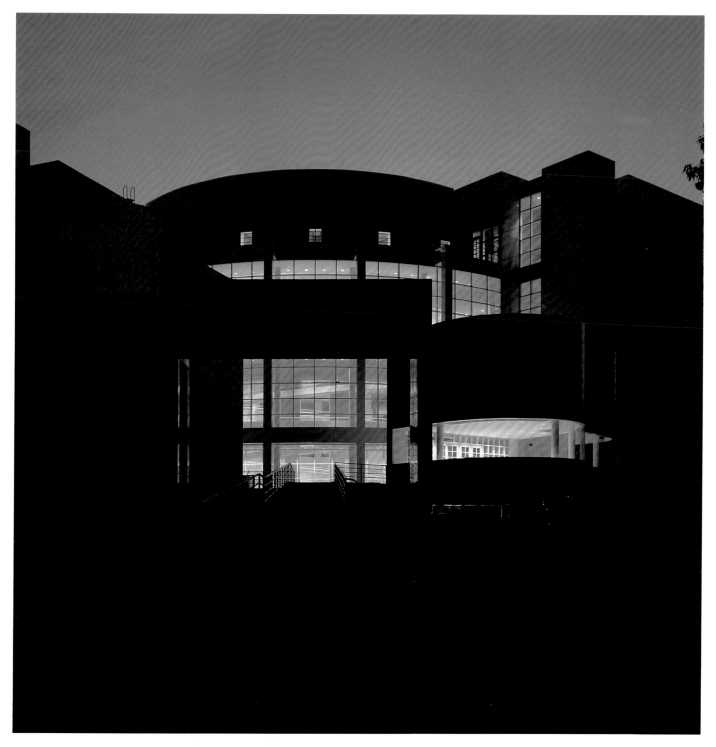

The new High Museum was the result of the efforts of many dedicated workers, volunteers and professionals who guided the course of fund raising, design and construction.

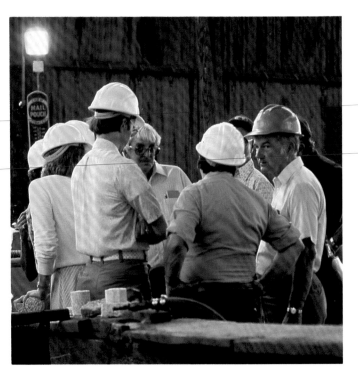

Major Donors to the Campaign for the New High Museum

The High Museum of Art and the community are greatly indebted to all donors and workers who contributed to the expansion process. This listing*gives special recognition to those whose major donations formed the financial base of the project.

Francis L. Abreu Charitable Trust
Accent Moving Services, Inc. (Agent: Allied Van Lines)
Charles S. Ackerman
Mr. and Mrs. William Addams
Allen Foundation
Allstate Insurance Company
AT&T
Mr. and Mrs. Anthony Ames
Amoco Foundation, Inc.
Arthur Andersen & Co.
Atlanta Falcons Foundation
Mr. and Mrs. J. Paul Austin

Barbara and Ronald Davis Balser
Bank South
William Nathaniel Banks
Mr. and Mrs. Charles C. Barton
Beers Construction Company
Mrs. Russell Bellman
Mrs. Joseph H. Boland
Mr. and Mrs. Albert J. Bows, Jr.
Mr. and Mrs. M. William Breman
Mr. and Mrs. George Brown, IV
Dr. Robert L. Bunnen and Lucinda W. Bunnen

Callaway Foundation, Inc., LaGrange, Georgia
Mr. and Mrs. Michael C. Carlos
Carter & Associates, Inc.
Mr. and Mrs. Frank Carter

Mr. and Mrs. Dave Center
The Honorable Anne Cox Chambers
Dr. and Mrs. Neal Chandler
The Chatham Valley Foundation, Inc.
Chevron U.S.A. Inc.
Citizens and Southern National Bank
Dr. and Mrs. Newton T. Clark
The Coca-Cola Company
Mrs. Emory Cocke
Judith and Stanley A. Cohen
Mr. and Mrs. Richard W. Courts
Mr. and Mrs. Thomas G. Cousins
Cox Communications, Inc.
The James M. Cox Foundation of Georgia, Inc.
Mr. and Mrs. Tench C. Coxe
Mrs. James H. Crawford
Frank and Ann Critz
Laura and John L. Crouse

Mr. and Mrs. Alfred A. Davis
Davison's
Days Inns of America, Inc.
Delta Air Lines, Inc.
Mr. and Mrs. H. Talmage Dobbs, Jr.
Mr. and Mrs. John R. Donnell, Jr.
Mrs. C. Warren Dukehart

Mr. and Mrs. Edward E. Elson
Equifax Inc.
Ernst & Whinney

Mr. and Mrs. Alvin M. Ferst
M & H Ferst Foundation, Inc.
R & J Ferst Foundation, Inc.
The First National Bank of Atlanta
The Atlanta Foundation
Price Gilbert, Jr. Charitable Fund
Ida A. Ryan Charitable Trust

*current as of date of publication

National Endowment for the Arts
National Service Industries, Inc.
Neiman-Marcus, Atlanta/
 HMA Members Guild
Mr. and Mrs. H. Burke Nicholson, Jr.
Mrs. Charles B. Nunnally

Mr. and Mrs. Charles V. Parham
Mr. and Mrs. Hermann Paris
Mr. and Mrs. William A. Parker, Jr.
Patterson Barclay Memorial Foundation
Peat, Marwick, Mitchell and Co.
Mr. and Mrs. Rhodes L. Perdue
Mr. and Mrs. John C. Portman, Jr.
Price Waterhouse
Mr. and Mrs. William C. Rawson
Mr. and Mrs. Louis Regenstein
Mr. and Mrs. Philip A. Rhodes
Rich Foundation
Rich's
Dr. and Mrs. John C. Rieser
Mrs. Katherine M. Riley
Mrs. Harris Robinson
Mr. and Mrs. J. Mack Robinson
The Josephine C. Robinson Foundation and
 Mr. and Mrs. A. Anderson Huber
Dr. and Mrs. Arnold B. Rubenstein

Salomon Brothers Inc
Sheila and David Saul
Dr. and Mrs. Michael Schlossberg
Mr. and Mrs. Richard N. Schwab
Scientific-Atlanta, Inc.
Sears, Roebuck and Co.
Mr. and Mrs. Simon S. Selig, Jr.
Mr. and Mrs. Grant G. Simmons, Jr.
Mrs. Robert R. Snodgrass
Southern Bell
Mr. and Mrs. Francis Storza

Sundown Fund—Metropolitan Atlanta
 Community Foundation, Inc.

Mr. and Mrs. Albert C. Tate, Jr.
Mrs. Alfred E. Thompson, Sr.
Dr. and Mrs. Barrie Thrasher and Family
Kate and Elwyn Tomlinson Foundation, Inc.
Transus, Inc.
Trust Company Bank
 Trust Company of Georgia Foundation
 Florence C. & Harry L. English
 Memorial Fund
 Harriet McDaniel Marshall Trust in
 Memory of Sanders McDaniel
 Walter H. & Marjory M. Rich
 Memorial Fund
J.M. Tull Foundation

Mrs. Ralph K. Uhry

WSB/TV Auction/HMA Members Guild
Gertrude and William C. Wardlaw Fund,
 Inc.
Mrs. William E. Waters
Dr. and Mrs. Robert E. Wells
West Point-Pepperell Foundation, Inc.
Western Electric Company
Mr. and Mrs. John F. Wieland
Mrs. Lawrence Willet
Mrs. Thomas L. Williams, Jr.,
 Mrs. D. Williams Parker, and
 Thomas Lyle Williams III
Mr. and Mrs. William D. Williams
Robert W. Woodruff
 Joseph B. Whitehead Foundation
 Trebor Foundation
 Lettie Pate Evans Foundation

Harriet and Jerome Zimmerman

Owner and Client	Atlanta Arts Alliance, Inc.	L. L. Gellerstedt, Jr., *Chairman (1977–1980)* L. Edmund Rast, *Chairman (1980–1983)* Ivan Allen, III, *Chairman (1983–1986)* Charles R. Yates, *President*
	High Museum of Art	Albert J. Bows, Jr., *President, Board of Directors* Gudmund Vigtel, *Director*
76 **Architect**	Richard Meier & Partners, Architects *New York, New York*	Richard Meier, FAIA, Gerald Gurland, AIA, *Principals-in-Charge* Philip Babb, Susan Berman, Michael Palladino, *Associates-in-Charge* Stanley Allen, Andrew Buchsbaum, David Diamond, Steven Forman, George Kewin, Dirk Kramer, Hans Li, Richard Morris, Vincent Polsinelli, James Tice, Greta Weil
Consultants	Consulting Architects	Jova Daniels Busby Architects *Atlanta, Georgia*
	Structural Engineers	Severud-Perrone-Szegezdy-Sturm *New York, New York*
	Mechanical and Electrical Engineers	John L. Altieri, P.E. *Norwalk, Connecticut*
	Lighting Consultants	George Sexton Associates *Washington, D.C.*
	Landscape Architects	The Office of P. DeBellis *White Plains, New York*
	Graphics Consultants	Whitehouse & Katz, Inc., *New York, New York*
	Model Maker	Albert Maloof *New York, New York*

General Contractor	Beers Construction Company *Atlanta, Georgia*	Lawrence L. Gellerstedt, Jr., *President,* *Beers, Inc.* Herbert D. Edwards, *President, Beers* *Construction Company* Richard Redmon, *Vice President, Beers* *Construction Company* Lawrence L. Gellerstedt, III, *President,* *BCB Company* Doug Burcher, *Vice President,* *BCB Company* Sam Gude, *Project Manager* Chuck O'Bryan, John Lee, *Superintendents*
Subcontractors	Mechanical	Mallory and Evans, Inc. *Decatur, Georgia*
	Electrical	Inglett and Stubbs, Inc. *Atlanta, Georgia*
	Skylights	Super Sky Products, Inc. *Thiensville, Wisconsin*
	Handrails	Standard Iron & Wireworks Co., Inc. *Chattanooga, Tennessee*
	Porcelain Panels	John S. Frey Porcelain, Inc. *Conyers, Georgia*
	Granite	The North Carolina Granite Corp. *Mt. Airy, North Carolina*
	Granite and Terrazzo	Williams Tile and Terrazzo Co. *Smyrna, Georgia*
	Carpet	Stratton Industries *Cartersville, Georgia*
	Flooring	Southeastern Flooring Company *Atlanta, Georgia*
	Structural Steel	Owen of Georgia, Inc. *Lawrenceville, Georgia*
	Concrete	Williams Brothers Concrete Co. *Atlanta, Georgia*
	Exhibit Fabricator	Rathe Productions Inc. *New York, New York*
	Sign Fabricator	Apco Graphics, Inc. *Atlanta, Georgia*